LONDON'S HISTORIC RAILWAY STATIONS

THROUGH TIME

John Christopher

AMBERLEY

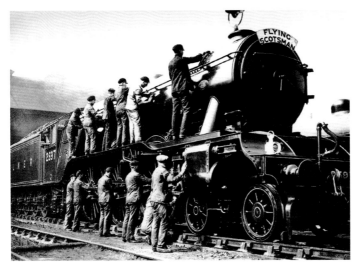

Left: In this pre-war publicity photograph a team of cleaners are polishing No. 2597 *Gainsborough* in front of the Top Shed at King's Cross. This locomotive was an LNER Gresley Class A1/A3, later renumbered as 60086 by British Rail and withdrawn in 1963.

About this book

The illustrations in this book encourage the reader to explore many aspects of London's major railway stations. They seek to document not only their history, their architecture and the changes that have occurred over the years, but also record something of the day-to-day life of these important railway termini. Hopefully they will encourage you to delve a little deeper when exploring the stations and their environs, but please note that public access and photography are sometimes restricted for reasons of safety and security.

First published 2015

Amberley Publishing
The Hill, Stroud
Gloucestershire, GL5 4EP

www.amberley-books.com

Copyright © John Christopher, 2015

The right of John Christopher to be identified as the Author of this work has been asserted in accordance with the Copyrights, Designs and Patents Act 1988.

ISBN 978 1 4456 5110 1 (print)
ISBN 978 14456 5111 8 (ebook)

British Library Cataloguing in Publication Data.
A catalogue record for this book is available from the British Library.

Typeset in 9.5pt on 12pt Celeste.
Typesetting by Amberley Publishing.
Printed in the UK.

Cathedrals of the Railways

London is encircled by some of the finest railway architecture to be found anywhere in the world. Sitting at the hub of the nineteenth-century transport revolution, the city was like a spider in a web made of railway lines that grew outwards to the far-flung corners of the nation. The great termini were built as statements, symbols of solidity and corporate greatness. Designed to impress, they were bold exclamation marks at the end of the line, announcing the railway's and the passengers' arrival in the greatest capital city in the world. As the late Sir John Betjeman, a Poet Laureate and a man who knew and loved railways, once famously stated, 'If the station houses are the equivalent of parish churches, then the termini are the cathedrals of the Railway Age. Most companies, even if their origins were in provincial towns, were determined to make a big splash when they reached the capital.'

In 1846 the Royal Commission on Railway Termini attempted to ring-fence central London, protecting it from invasive railway construction, in particular by limiting all new works to the north side of the Euston Road. As a result the termini are laid out in a neat ring with only some of the later lines tentatively pushing their noses up from the south to cross the Thames. Accordingly, the thirteen principal termini are covered in a clockwise order starting with Victoria in the west, then Paddington and along the Euston Road to include Marylebone, Euston, St Pancras and King's Cross, with Liverpool Street and Fenchurch Street to the east, before

Below: William Henry Barlow's great train shed at St Pancras under construction, with the ribs projecting upwards on either side. Its single-span roof was the widest in the world. The rail deck was supported by fifteen rows of iron columns forty-eight deep. *See page 43.*

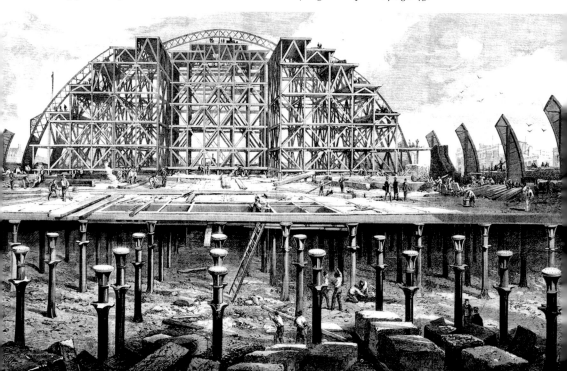

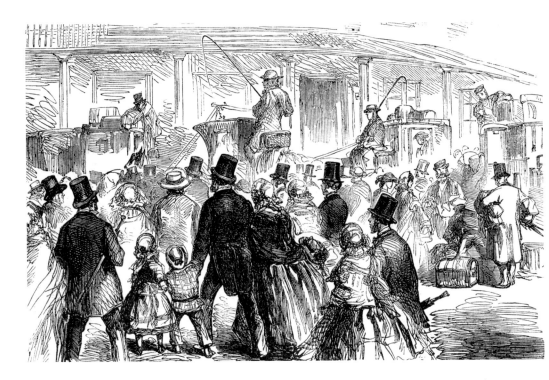

The transport revolution was about more than the arrival of the steam engine. In London in particular it brought unprecedented changes in the way people lived and how they worked. Many parts of the city were reshaped, with tens of thousands of people uprooted from their communities. *Above*: Fashionable travellers at London Bridge in 1858. *Below*: 'Over London by Rail.' Gustave Doré's illustration of closely packed houses in the shadow of the railway.

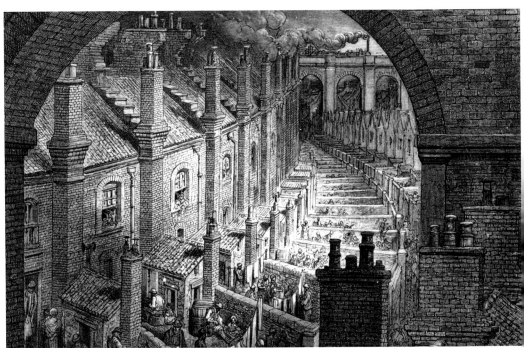

Above: Bacon's map of London, 1899, showing the principal railway lines and stations.

continuing back into the City along the north bank of the Thames for Cannon Street, Blackfriars (Holborn Viaduct) and Charing Cross. South of the river, going from east to west, we conclude with London Bridge and Waterloo.

Most of these termini have seen change to a greater or lesser extent. Some rebuilds took place in the nineteenth century as the companies, short of cash after constructing the lines into London, had little left to build a grand terminus. (This not only applied to the smaller companies, but also to the Great Western Railway at Paddington.) Others grew in piecemeal fashion into an unworkable mishmash of platforms and buildings. This was the case with the present Waterloo which is, in essence, an Edwardian structure. For others change came with the drive for modernisation in the twentieth century. Even before the Second World War plans were mooted for several stations, while the post-war creation of British Railways intensified the calls to modernise them and do away with the old-fashioned Victorian structures. Many of the great termini were threatened with the wrecking ball. Euston succumbed, and at Victoria invasive development creep has ruined the station apart from the retained façade, and both Cannon Street and Charing Cross have been roofed-in. Despite this there is cause for optimism. Paddington, King's Cross and St Pancras have been transformed with an intelligent integration of new architectural features, while Blackfriars and London Bridge have been reborn as exciting new stations. Inevitably, time will bring further change, but there is still so much to see and appreciate in these cathedrals of the railway age.

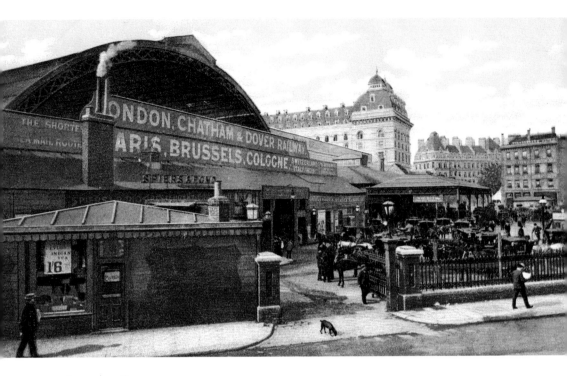

A split personality

Above: Victoria was a battleground between rival neighbours, the LCDR (later SECR) and the LBSCR. This early postcard shows the ramshackle collection of buildings facing onto the station yard. *Below*: An 1869 plan of Victoria, together with a British Rail Southern leaflet from the 1960s which shows the shortened spans of the SECR roof in their post-war state.

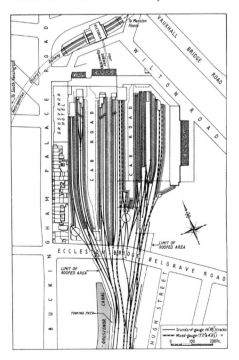

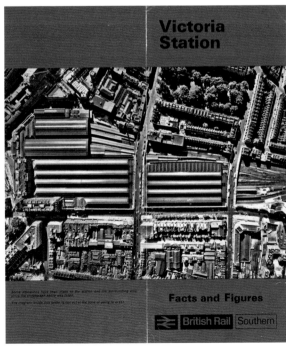

Victoria

This station has a split personality. It was built in two distinct and separate halves. One was for the London, Brighton & South Coast Railway (LBSCR) and the other for the London, Chatham & Dover Railway (LCDR) which became the South Eastern & Chatham Railway (SECR). The site was the former Grosvenor Canal basin in Pimlico and the two railways shared access across the Thames, from the Battersea side, via the Grosvenor Bridge completed in 1860. Doubled in width six years later, it was rebuilt entirely in the 1960s.

Each station had its own characteristics. The LDCR station had elegant curved arches of wrought iron, designed by Sir John Fowler, while the roof on the LBSCR's 'Brighton side' was of a no-nonsense five-ridge and furrow design with deep lattice girders supported on cast iron columns. The rivalry between the two companies was intensified in 1889 when the the LBSCR instigated a major rebuild and the old station frontage was pulled down to be replaced by a grandiose extension to the neighbouring Grosvenor Hotel designed by Charles L. Morgan in high Edwardian Baroque. This was completed in 1906. Not to be outdone, the LDCR responded with a new frontage of its own designed by Alfred W. Blomfield and W. J. Ancell. This was a magnificent, if somewhat over-blown, vision of Baroque opulence complete with curvacious caryatids.

With its connection to Dover the now SECR's station became known as the 'Gateway to the Continent' and by the 1930s the Cross-Channel service had reached its zenith with the Golden Arrow express and the new Night Ferry which saw the carriages, complete with sleeping (if that's possible) passengers, loaded on to special ferries. But by then there had been big changes at Victoria. Under the Grouping of Britain's railways in 1923 Victoria's rival companies became part of the Southern Railway and arches were opened up in the dividing wall to make the two stations into one. The platforms were renumbered from 1 to 17 starting from the eastern side.

Time has not been kind to Victoria. In the Second World War the Luftwaffe did its best to re-model it by truncating the old SECR arches, but it was the British government and the newly formed British Railways that caused the biggest shake-up. In a spirit of post-war optimism there were calls for the entire station to be swept away during the 1950s and 1960s. It survived only to suffer a slow lingering death through the piecemeal encroachment of commercial building – development creep – which has left this old friend permanently scarred. A concrete slab was built across the end of platforms 15–17 to support a new eight-storey office block, and in 1980 plans were unveiled for a major 'reconstruction' of the terminus. The south train shed, which stretched as far as Elizabeth Bridge, was demolished and replaced with a 'raft' of concrete supporting a shopping centre and offices. The result, claimed one critic, made the place feel like a multi-storey car park. More recently the SECR roof has undergone renewal and there has been a £509-million programme upgrade of the Underground station.

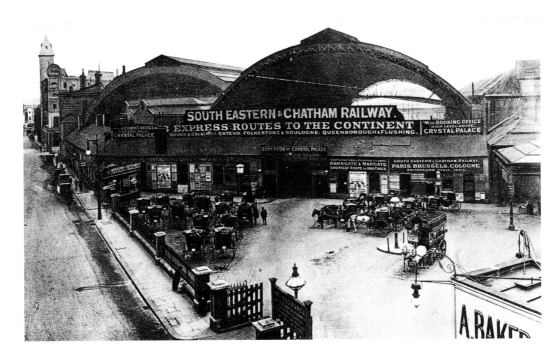

The SECR station

Two views looking into the station yard, with Wilton Road to the left. They were taken either side of the 1909 rebuild of the old London, Chatham & Dover Railway's frontage. The twin arches of the iron roof are visible in the upper image. By 1899 the management of the LCDR had amalgamated with the South Eastern Railway to create the South Eastern & Chatham Railway (SECR).

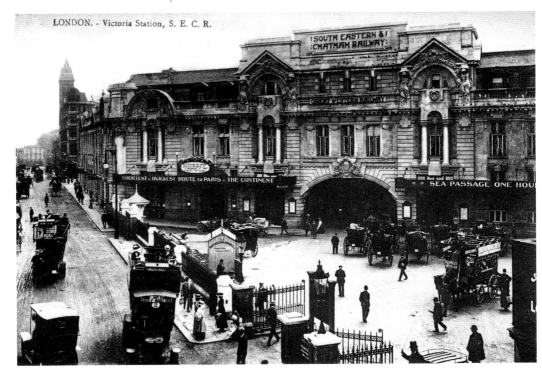

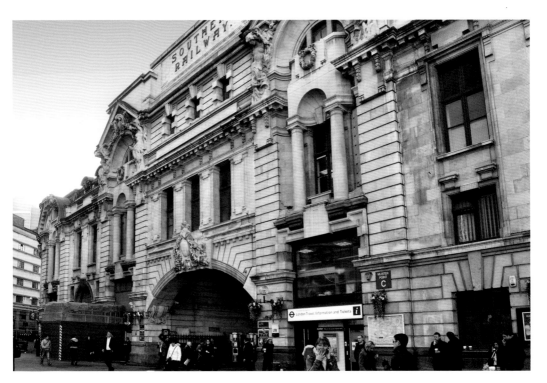

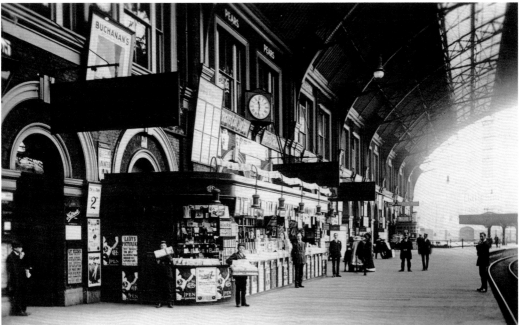

Top: If the SECR couldn't compete with its nine-storey neighbour in terms of scale, then its designers, Alfred W. Blomfield and W. J. Ancell, resolved to out-style it with all the architectural bling at their disposal. Completed in 1909, it boasts a wide archway, Ionic columns, pediments and busty mermaids. The Southern Railway applied its name following the 1923 Grouping of Britain's railways. *Bottom*: W. H. Smith's newsagent's booth beneath the elegant arches of the SECR's roof.

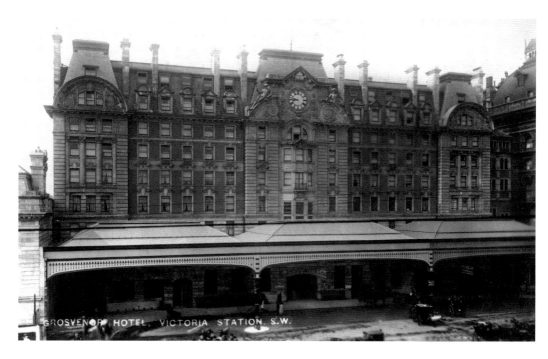

The LBSCR station

Designed by Charles L. Morgan and completed in 1908, the upper storeys of the LBSCR building contain an annexe to the Grosvenor Hotel, which is why it so closely mimics the hotel's styling. Beneath the French mansard roofs its red brick is alleviated by ashlar end pavilions and a centrepiece clock flanked by reclining statues. The result is an expression to Edwardian pomposity which has been unkindly likened to a 'gigantic overmantle'.

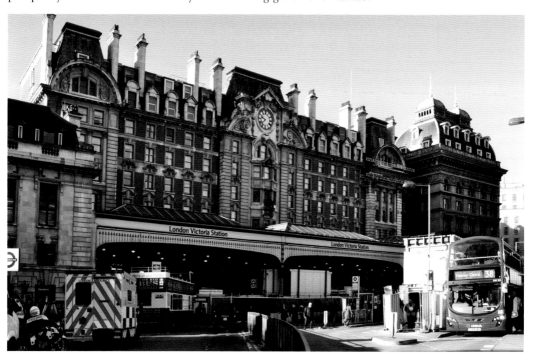

The main LBSCR train shed consisted of five ridged roofs with deep lattice girders supported on cast iron columns and the surrounding structure, covering four platforms. *Right*: An illustration from May 1861 showing the newly opened terminus at Pimlico – the old name for the area.

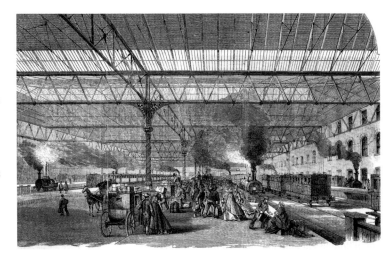

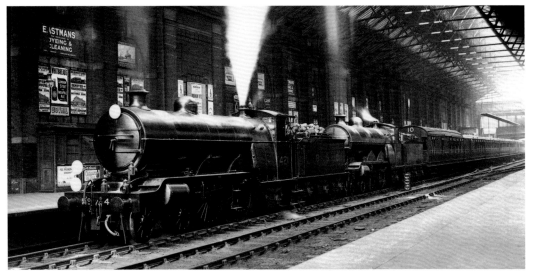

Above: A superb view of a double-header waiting at Victoria, *c.* 1915. The lead loco is No. 421 *South Foreland*, an H2 class built at the Brighton Works.

Right: The roof was significantly truncated in the 1980s and the remaining section covers only the head of the platforms and the modern concourse area.

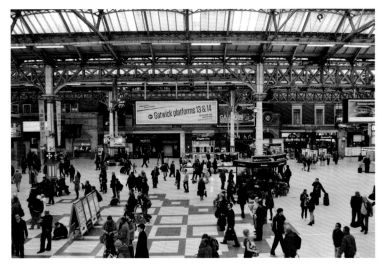

11

In 1923 years of rivalry at Victoria were put aside with the Grouping of Britain's railways. When both stations became part of the Southern Railway, openings were made in the dividing wall and the platforms were renumbered from 1 to 17.

Left: Following the end of the war nationalisation of the railways did not always result in a happy organisation. A major rail strike in 1955 left many travellers stranded, including Lotta Herchy and her son who are shown at Victoria in this press photo.

Right: This 1952 image of the Golden Arrow departing from Victoria features the clock tower of the Imperial Airways terminus. This had its own independant platform for passengers connecting with the company's flying boat service from Southampton.

Below: The Imperial Airways building on Buckingham Palace Road is now occupied by the National Audit Office. Viewed from Ebury Bridge, the tower still stands out although it is surrounded by later buildings.

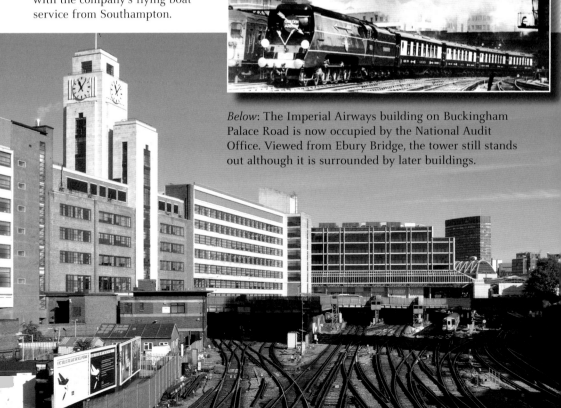

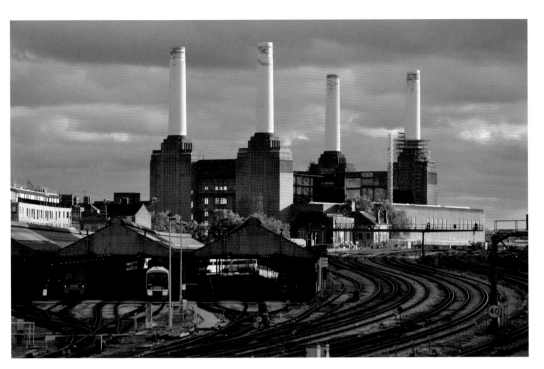

The approach

Above: Looking southwards with the sheds of the Grosvenor Road Carriage Sidings on the eastern side of the lines. In the distance, on the other side of the river, the four 'table legs' of the Battersea Power Station still dominated the skyline in this 2012 photograph, taken before their removal and reconstruction.

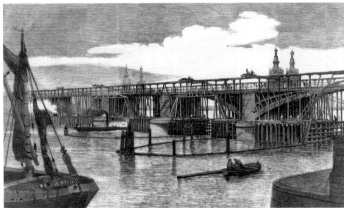

Left: The Grosvenor Bridge, or the Victoria Railway Bridge as it is generally known, was the first rail crossing over the Thames. Designed by Sir John Fowler and consisting of four arches of wrought iron, it was completed in 1860 and widened six years later. It was rebuilt in steel and concrete in the 1960s.

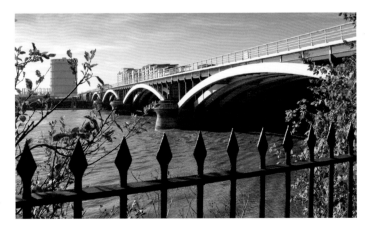

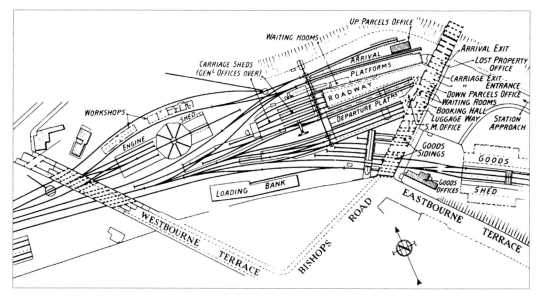

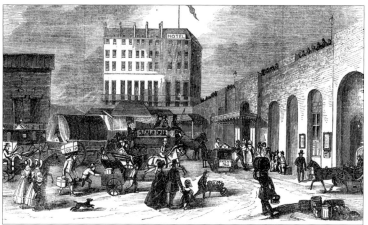

Above: The original GWR station at Paddington was located on the northern side of the Bishop's Road bridge. Note the circular train shed designed by Daniel Gooch.

Middle left: The bridge, built by the GWR as part of the agreement to use the land, became the public frontage to the original station.

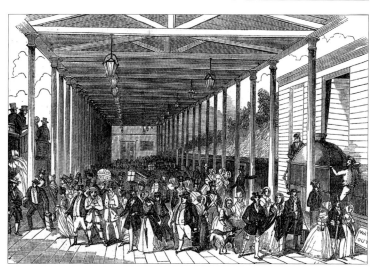

Bottom left: In this engraving from 1843, the temporary nature of the timber station buildings is evident.

Opposite page: The view looking under the present bridge from the end of Platform 1, with a cluster of First Great Western HST 125s.

Paddington

'I am going to design, in a great hurry, and I believe to build, a station after my own fancy; that is, with engineering roofs, etc. etc. It is at Paddington, in a cutting, and admitting of no exterior, all interior and all roofed in.'

It is not often that an engineer gets a second take on a major project, but that is exactly what happened with Isambard Kingdom Brunel and the Great Western Railway's terminus at Paddington. As Brunel states, the plot was in a cutting, tucked beneath a spur of the Grand Junction Canal, but at the time of the railway's construction neither the finances nor the land available could provide the terminus that such a 'Great' undertaking deserved. Instead a makeshift station was constructed on the north side of the Bishop's Road bridge, which the GWR had been required to build across the site. This bridge, and its mutiple arches, provided acess to the station and even housed the booking hall and waiting rooms. The station itself was a collection of timber platforms protected from the elements by simple wooden roofs. It opened for business in June 1838, although initially the trains – built to Brunel's broad gauge of course – ran only as far as Taplow, near Maidenhead. A goods shed and a polygonal engine house, designed by the company's locomotive superintendant Daniel Gooch, were also constructed. As the traffic increased the cluster of wooden structures soon proved woefully inadequate and in late 1850 the company directors gave the go-ahead for the construction of a new terminus, thus prompting the words quoted above.

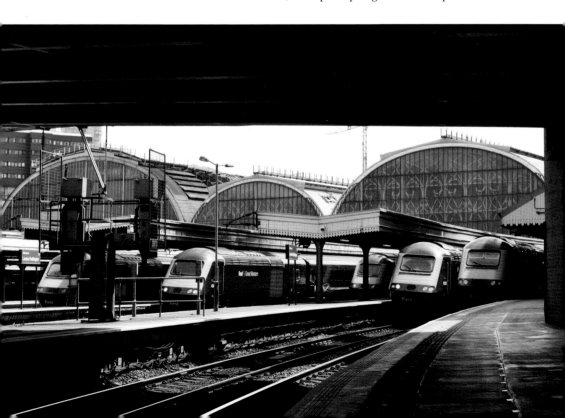

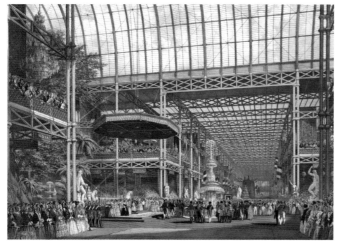

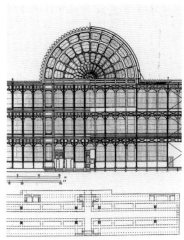

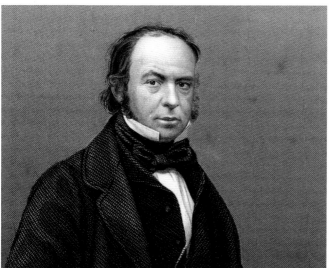

Brunel's greenhouse
When the land and finances became available for the building of the New Paddington station, the GWR's engineer Isambard Kingdom Brunel, shown left, was able to draw upon the latest developments in wrought iron construction to create a station with 'engineering roofs'.

Top: Although there were a number of other significant iron and glass buildings, it was Joseph Paxton's design for the Crystal Palace to house the Great Exhibition of 1851 that refined the techniques for prefabricated construction on this scale.

Bottom left: A contemporary engraving of the newly opened station looking towards the 'country' end with the arches of the Bishop's Road bridge in the distance. Brunel's slender iron columns are shown, although they were later replaced by beefier steel columns in a process completed in the 1920s.

In the years since the opening of the railway great strides had been made in the construction of large structures in wrought iron and glass. Paxton's Crystal Palace for the Great Exhibition of 1851 obviously comes to mind, but there were others including the 363-foot-long Palm House at the Royal Botanical Gardens at Kew, which was completed in 1848. Brunel was certainly aware of these advances, and as a member of the Building Committee appointed to chose the design for the Great Exhibition, he enjoyed a friendly working relationship with Paxton.

The roof of the 'New' Paddington train shed consists of three parallel transepts, or spans, each 700 feet long. The central one is the biggest at 102 feet 6 inches wide, and it is flanked by two smaller spans of 70 feet, making it the largest train shed in existence at the time it was built. Each transept consists of curved wrought-iron girders – much like the ribs of an upturned boat – spaced 10 feet apart, which were supported on iron columns (later beefed up with steel replacements). Adding to the church-like impression, the spans are punctuated by crossways transepts, 50 feet wide, at one-third intervals lengthwise. One is aligned with the Moorish windows of the Directors' Room overlooking the Departures Platform, or Platform 1. To complete much of the decorative detailing Brunel called upon the architect Matthew Digby Wyatt, not because he was incapable of the work himself but because he was too busy at this point in his career. Digby Wyatt provided the petal-like embellishments on the arches and the fine tracery at the gable end of the spans. The fourth span was added in 1916 and although it generally mimics Brunel's styling it is slightly bigger and the ribs are of plate steel girder rather than iron.

Instead of the grand frontage on Praed Street as envisioned by Brunel, the directors decided to build a hotel as was common practice with many of London's termini. This was designed by Phillip Charles Hardwick in the French Second Empire style and opened in 1854. The main entrance to the station is from Eastbourne Terrace leading on to Platform 1.

Below: The site of the original Paddington station is marked on this later map as 'Railway Depot', with the New Paddington is indicated in pink. Note how the lines make a sharp turn to the right as they approach the station under the bridge.

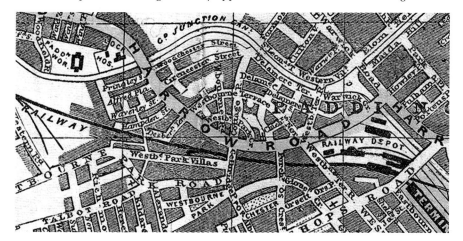

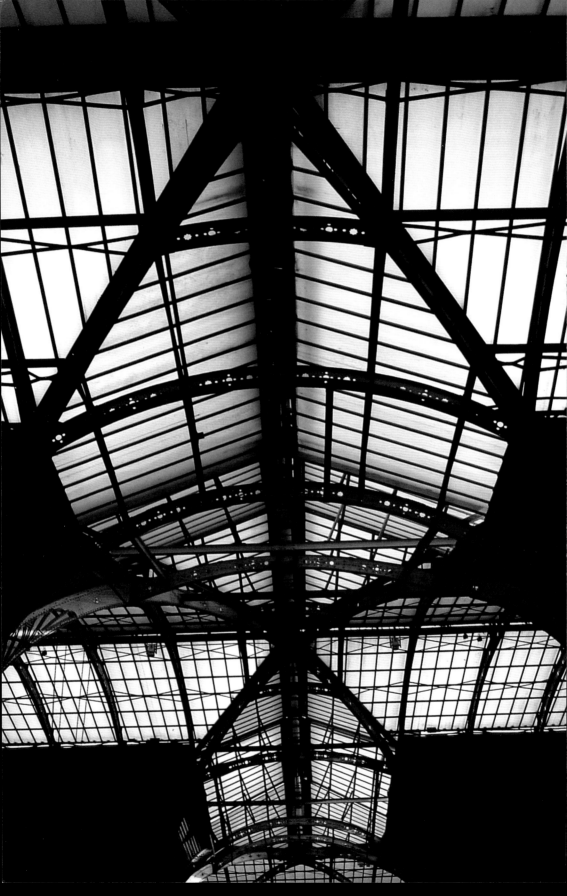

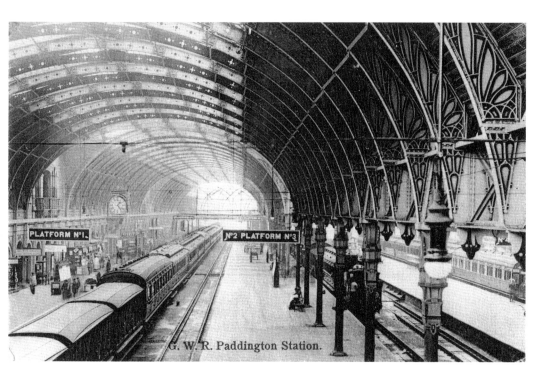

G. W. R. Paddington Station.

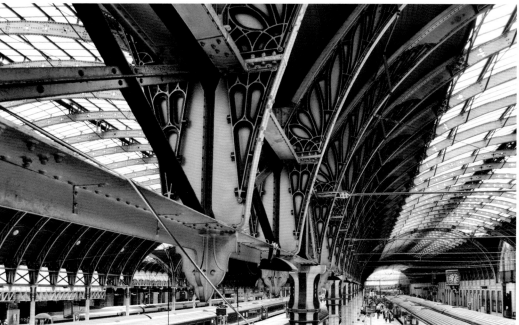

Above: The curved arches are spaced at 10-foot intervals and rest on iron columns 30 feet apart. Between each pair of columns are two 'floating' arches supported by cross-braced girders between the column heads. The petal design, cast in iron, strengthens the base of the arches and was designed by Matthew Digby Wyatt, who assisted with architectural detailing.

Opposite: Intersection where the main spans meet one of the two crossways transepts.

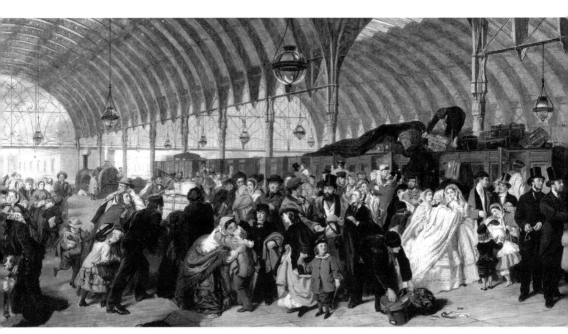

Above: Artist William Powell Frith's celebrated depiction of Paddington station viewed from Platform 1. There is a broad gauge locomotive at the head of the train.

Left: Embellished in a Moorish style, the balcony of the Directors' Room looks out across the busy platforms.

Below: The recent refurbishment has decluttered the platforms.

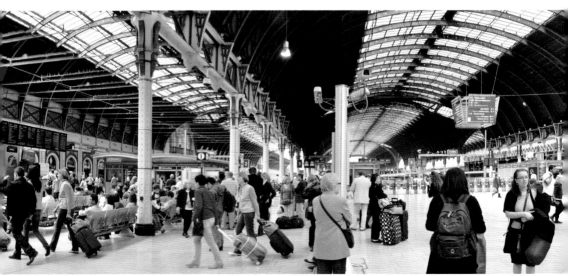

Top right: Platform 1 was also known as the Grand Departures Platform thanks mainly to its royal associations, as it served both Windsor and Eton School. This postcard from *c.* 1910 shows the station swarming with straw-hatted schoolboys.

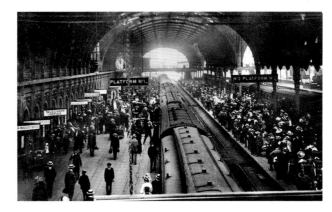

Middle right: The decorative scrolling – also designed by Matthew Digby Wyatt – provide additional stiffening at the end of the main transepts.

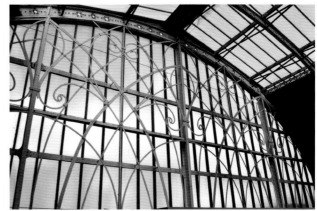

The 1990s saw an extensive refurbishment of the station including the resurfacing of the platform and concourse floors with limestone, renovation of the roof and metal tracery, and a general decluttering with the removal of the cumbersome destination boards to open up the view of the station interior. The 'Lawn' area of the concourse, shown bottom right, was revamped as an oasis of calm for a new breed of twenty-first-century cappuccino-sipping rail travellers.

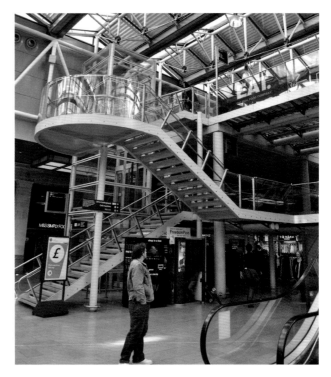

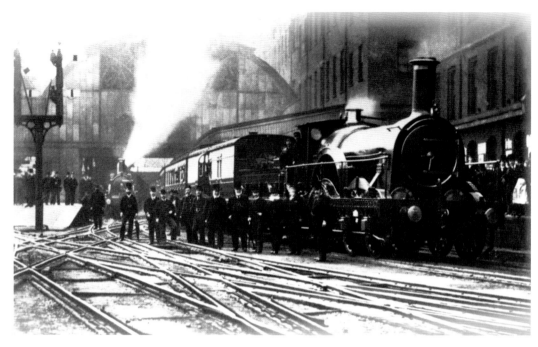

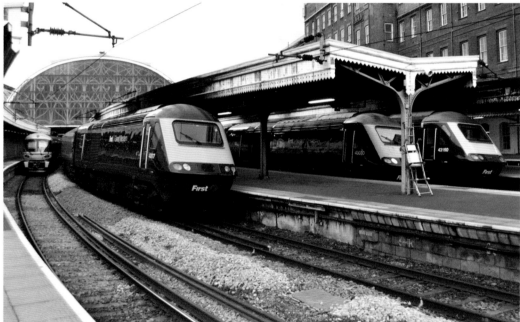

Broad gauge departure

Two views looking across to Platform 1. *Top*: Brunel's great experiment, the broad gauge of just over 7 feet, was thwarted when a Parliamentary enquiry in 1846 came down in favour of the narrower so-called 'standard' gauge of around 4 feet 8 inches. This photograph from 20 May 1892 shows the Cornishman, the final broad gauge express, departing from Paddington. The dark brickwork on the right is the back of the buildings on Eastbourne Terrace. *Bottom*: A group of modern HSTs.

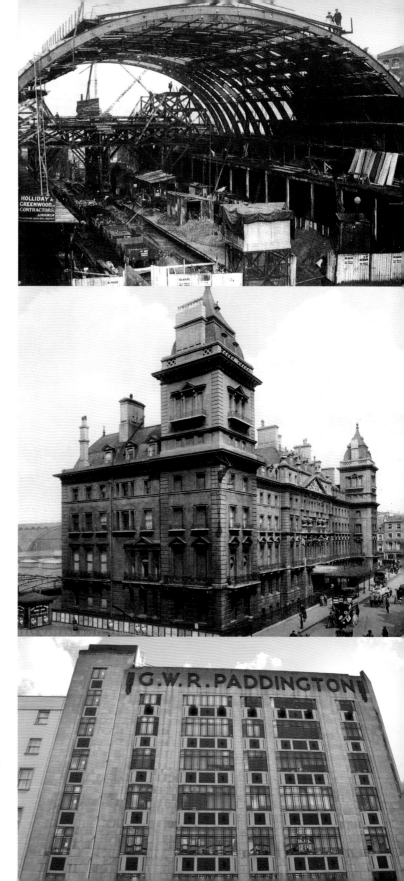

Top right: Paddington's fourth span on the north side of the station was begun in 1913 and was completed in 1916. Designed by the GWR's engineer W. Armstrong, it largely mimics Brunel's original spans, but in steel-plate girder rather than iron. The end of the span nearest to the sloping Arrivals Road is tapered to the shape of the site. *(Network Rail)*

Middle right: For a station with no recognisable façade, the Great Western Royal Hotel on Praed Street was a bold architectural statement to announce its presence. Brunel had no hand in its design, which was undertaken by Phillip Charles Hardwick, and the result is an imposing building with corner towers in the French Second Empire style. It opened in 1854 and although managed separately from the railway, its first chairman happened to be Brunel. It saw a major refurbishment in the 1930s with new interiors in the art deco style. *(LoC)*

Bottom right: Completed in 1935, Tournament House provided additional office space on the upper storeys and a new buffet and tea room opening on to the Lawn at ground level.

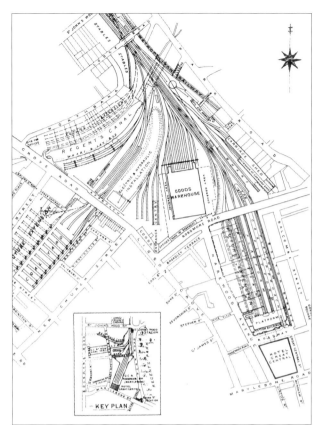

A modest latecomer
Left: Map of Marylebone with the station and hotel bottom right.

Above: Station sign for Chiltern Railways and the Underground.
(Elliott Brown)

Below: Postcard view of the station concourse, *c.* 1905.

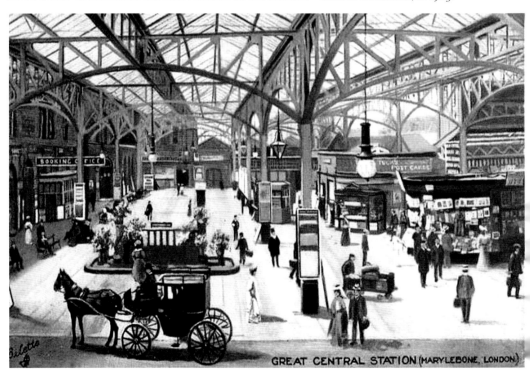

GREAT CENTRAL STATION (MARYLEBONE, LONDON.)

Marylebone

Marylebone is a modest affair and in comparison with London's other great mainline termini it has been likened to a station in a provincial town. It is said that this was the only one where a traveller might hear bird song. This was the last addition to London's termini – it opened to passengers in 1899 – and was built to fulfill the Great Central Railway's ambition of extending its lines into the capital. By then, however, land prices had soared and the GNR did not have the budget for a mighty edifice. Having said that, modesty is no bad thing and Marylebone has its own charms and is generally regarded as one of the calmest termini. Designed by the company's civil engineer, Henry William Braddock, Marylebone's station buildings are of warm brick and on a domestic scale that fits well in its urban location. Originally it was to have eight platforms, but as the purse string grew tighter this was reduced to just four. As a result the concourse is unusually long, although today there are six platforms serving the diesel-hauled trains of the Chiltern Main Line. Passenger numbers were never high and by the 1980s Marylebone was under threat of closure, or worse, conversion into a coach station!

The adjoining Hotel Great Central was not built by the railway company and was designed by Sir R. W. Ellis. Converted to offices, it became the headquarters of British Rail from 1948 to 1986. Restored to its former use in 1993, it is now known as The Landmark London, a luxury hotel with 300 rooms.

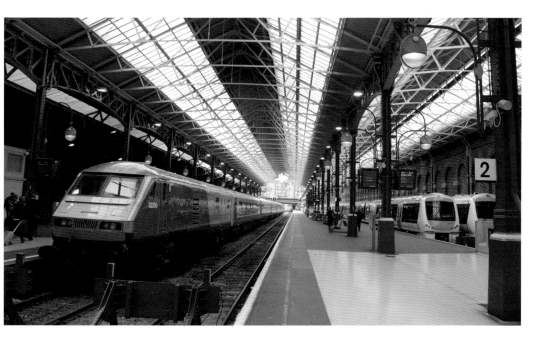

Above: Platforms 3, 2 and 1 at Marylebone, photographed in 2012. The roof of the train shed is workmanlike but unspectacular. *(Hugh Llewelyn)*

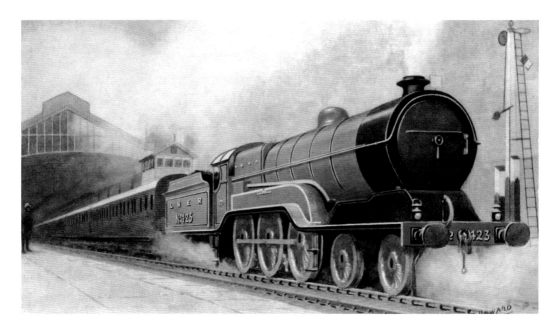

Above: Post-grouping LNER loco *Sir Sam Fay* hauling the Sheffield Express out of Marylebone, *c.* 1926 or 1927.

Left: Marylebone in 1981. Platforms 5 and 6 were added in 2006. *(Barry Lewis)*

Below: Chiltern Railways 68012, on Platform 3 in 2015. *(Paul David Smith)*

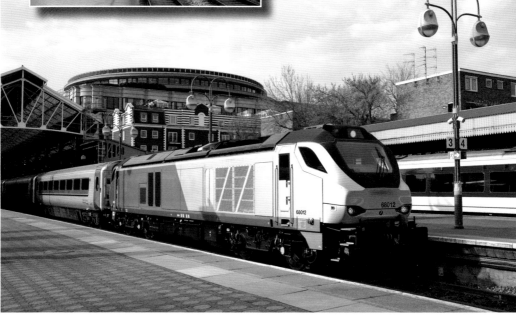

Top right: Marylebone is festooned with emblems of the Great Central Railway. Here is the monogram on a railing. *(Elliott Brown)*

Middle right: The exterior in warm brick and sandstone has been compared with a provincial library or a small town station. Note the porte cochère which provides a link between the station building, across the private road, and the hotel. *(Oxyman)*

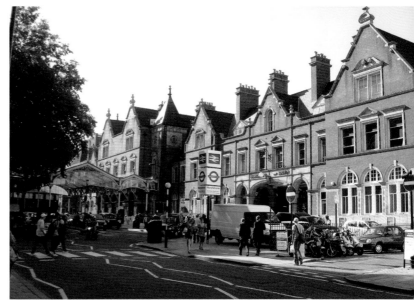

Bottom right: Arguably the most notable aspect of Marylebone's architecture is this 90-foot structure of iron and glass. It has been painted white in recent years. *(Jorge Royan)*

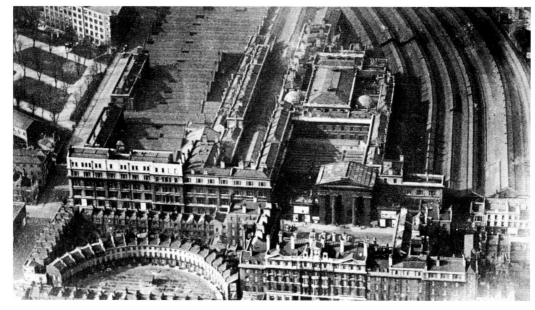

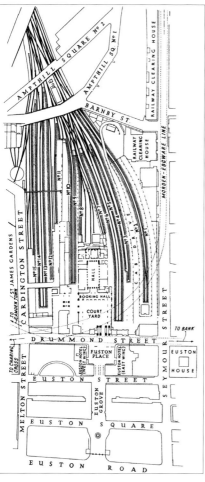

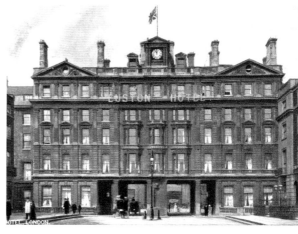

Euston

This aerial photograph looking north, shown top, helps to identify the various parts of the station depicted in the plan, shown left, published on the station's centenary in 1938. The famous Euston Arch faces on to Drummond Street and is located on the plan just above the second 'D'. The Great Hall is above the courtyard and behind the Booking Hall. Moving southwards from Drummond Street is Euston Place and the Euston Hotel, shown in this postcard above, which bridges Euston Grove. Note that the station and associated buildings are set back from Euston Road itself, with the small lodges on either side of a gated entrance (shown on the plan but cut off in the photograph).

Euston

Most of London's great stations have been under threat at some point, but alas it was Euston that first fell to the bulldozers in the post-war zeal for modernity. Built as the terminus of Robert Stephenson's London & Birmingham Railway in 1837, Euston was London's first intercity railway station. The train sheds were designed by Sir Charles Fox. An unusual feature of the early Euston was the absense of steam locomotives. Because it stood at the foot of a long 1 in 70 incline leading up to the yards at Camden, Stephenson installed a cable system by which the carriages were hauled up the hill with power coming from a winding engine at the top of the hill. As the early locomotives improved this unusual form of traction was done away with.

The London & Birmingham had a short life and after amalgamating with two other regional companies it emerged as the London & North Western Railway (LNWR) with its headquarters at Euston. This was at the height of the railway mania in the 1840s and the station was expanded to meet the increase in traffic. Other improvements included a new station entrance through the world's largest Doric propylaeum, which was designed by Philip Hardwick and became known as the Euston Arch. By the 1870s the site occupied upwards of 10 acres, and over the next two decades further platforms were added on the western side, with the final four completed in 1892. By the time of the Grouping of the railways and the creation of the London Midland & Scottish Railway (LMS), express trains were departing from Euston regularly on the West Coast Main Line through the major cities of England, including Birmingham, Manchester and Liverpool, on the way to Scotland. The company also ran the Irish Mail train from Euston to the boats at Holyhead.

Euston changed little under the management of the LMS apart from the construction of new company headquarters, Euston House, erected on Seymour Street in 1933. However, by the the time of the L&BR's centenary celebrations in 1935 the company was considering plans for reconstructing Euston on 'most modern' lines. The Second World War provided a temporary reprieve. After the war declining passenger numbers and the rise of the automobile spurred British Rail into a modernisation programme including a brand new Euston. This entailed the demolition of the famous arch and the creation of the modern concrete box station, which was opened by the Queen on 14 October 1968. The main concourse, covering an area of 30,000 sq ft, is an open two-storey space designed to accommodate the peak time crowds. The walls were to be entirely glazed to let light into other station areas, but the growth of signage and retail outlets has left the concourse a gloomy place, its concrete ceiling discoloured with time. It is fair to say that the present Euston, alone among London's termini, fails to present any redeeming features. Save one. It might be demolished when the new High Speed 2 rail link comes to town. Furthermore, we might even see a reconstructed Euston Arch back in its rightful place.

Above: The L&BR cutting out of Euston was a finely proportioned piece of architecture in its own right. In comparison the view looking north from the present station, shown below, is dominated by a forest of gantries and overhead cables. This Class 378 EMU is arriving on a suburban service in 2012. The modern signal box is on the left.

Top right: When Euston opened in 1838, the arrival and departure platforms were each served by two lines of track. Most of the carriages are shown as being open topped, and note the absence of locomotives.

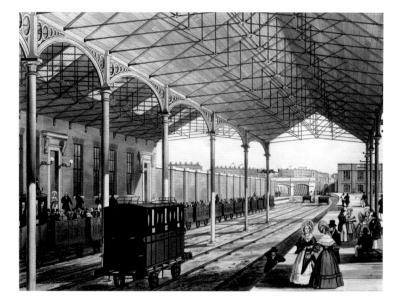

Middle right: The straight lines of the later LNWR platforms, in this case 12 and 13, are shown in this postcard view. The roof is an uncomplicated ridge and furrow design, functional but unexceptional.

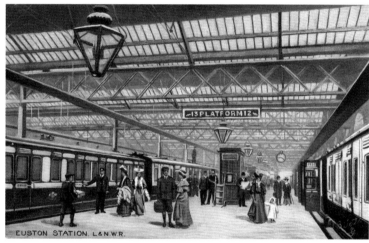

Bottom right: The modern post-rebuild platforms – there are eighteen of them – have no direct correlation with the old numbering. Platforms 9 and 10, shown here, still have that slight curve to them.

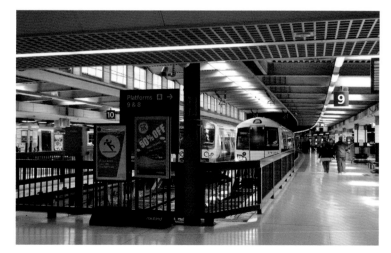

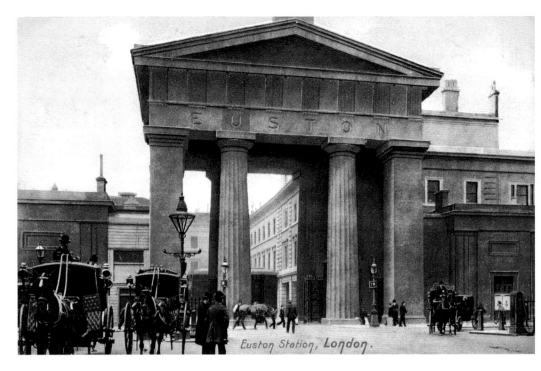

Euston Station, London.

The Euston Arch

Shown in this colour postcard from around 1905, the arch was designed by Philip Hardwick, and stood 72 feet high. Strictly speaking it is a propylaeum. A narrow staircase led to windowless offices in the pediment itself, and the square lodges to either side were also utilised.

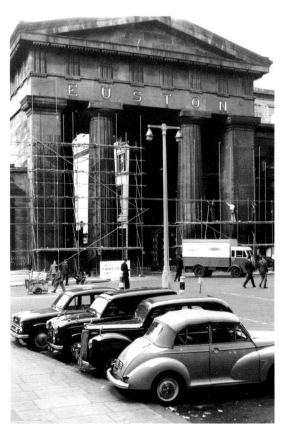

Left: The great arch became the most high-profile victim of the modernisation of Euston station. In 1961 the scaffolding went up so that the demolition team could get to work. Its destruction was brutal and ruthless, carried out in such a way that it could not be rescued. Many of the stones were dumped in the Prescott Channel in the East End and some have been salvaged in the hope that the arch will rise again in the event that Euston will be rebuilt, once again, to serve the new High Speed 2 service to Birmingham.

Top right: In 1869 the LNWR had acquired the strip of land that separated the station entrance from Euston Road. A new drive, Euston Grove, was formed and the entrance flanked by two lodges. The arch is seen in the distance, slightly to the right due to the alignment of the existing buildings. Compare this with the photograph overleaf on page 34.

Second right: In its day the LMS had harboured plans to replace the old Euston with flashy new headquarters. This illustration from 1935 depicts one of the proposed schemes. Luckily, the war kept the wrecking balls at bay.

Third right: A 1963 photograph showing a bulldozer getting to work on the platforms. 'Construction of piles, pile caps, footings and service trenches had to contend with a bewildering variety of obstructions,' it was stated by BR at the time. *(British Rail)*

Bottom right: This in turn modern building is the new Euston Power Signal Box on the western side of the tracks. This closed in 2000 when signalling passed to the Main Line Signalling Control Centre at Wembley.

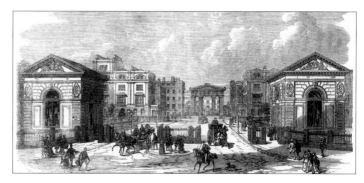

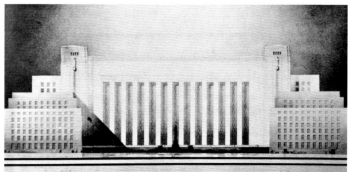

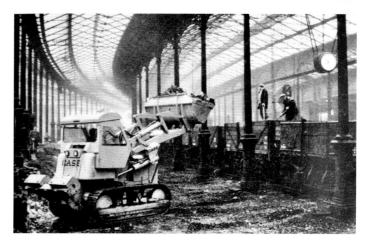

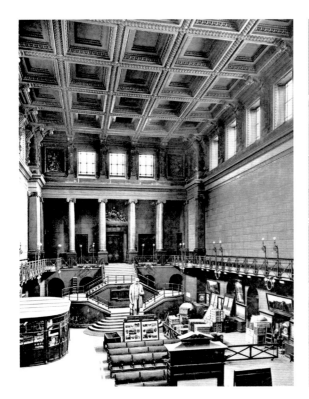
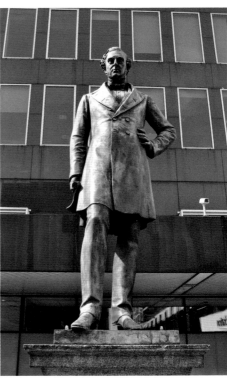

Above left: Few relics survive from Euston's Great Hall, designed by the younger Philip Hardwicke. The 1852 statue of George Stephenson is now at the National Railway Museum, York. *Above right*: The bronze statue which stands in the square in front of Euston is of Robert Stephenson. *Below*: Euston Grove photographed in 2012, with the two lodges and the LNWR's war memorial.

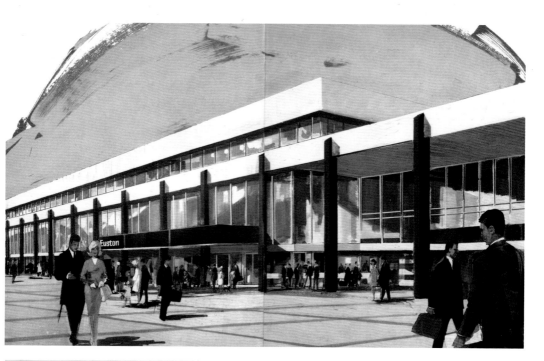

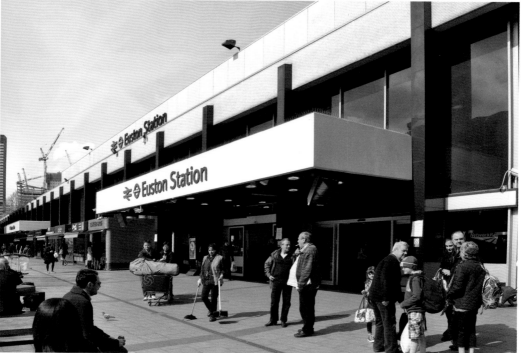

The new Euston

Above: 'Simplicity is the keynote in the design of the new Euston. The main entrance to the station for passengers arriving on foot is through doors in the colonnade which spans the station frontage and includes a number of shops... Its modern lines are uncluttered and the walls of the main concourse are filled with expanses of glass.' *Passengers Guide to Euston*, 1968.

Despite the intention to create a modern station, the result has all the charm of a provincial bus station. The daylight can't get through and the concrete roof bears down like a heavy overcast. The Travel Centre, shown top and middle left, is situated on the western side of the concourse, and has been restyled with only the egg-box ceiling remaining, a period gem from the 1960s.

Bottom left: Around the corner from the station is Euston House. In 1933 the LMS built itself this fine steel-framed office block in the moderne style. It still looks as good as the day it was built.

Top right:
No. 1395 *Archimedes*, of the LNWR's Dreadnought Class designed by F. W. Webb, shown at Euston. This locomotive was built at Crewe in 1886. Note the boards above the loco, which are designed to prevent the blast from the chimney damaging the roof.

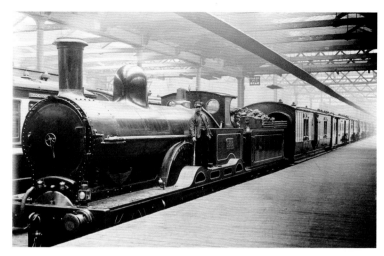

Lower right: No chance of damaging the roof on the rebuilt Euston as shown in this 1968 illustration. 5,500 tons of structural steelwork was needed to support the parcel deck on the floor above.

Below: Virgin Quest Pendolino at Euston.

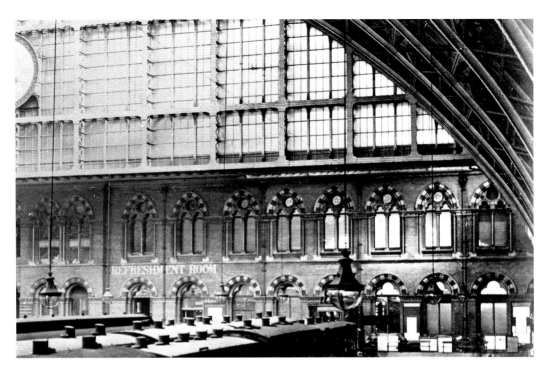

St Pancras – a survivor

Representing the zenith of high Victorian engineering and architecture, St Pancras has been transformed into a station fit for the twenty-first century. Once threatened with demolition, its survival is largely attributed to Sir John Betjeman, whose statue now gazes up at Barlow's roof.

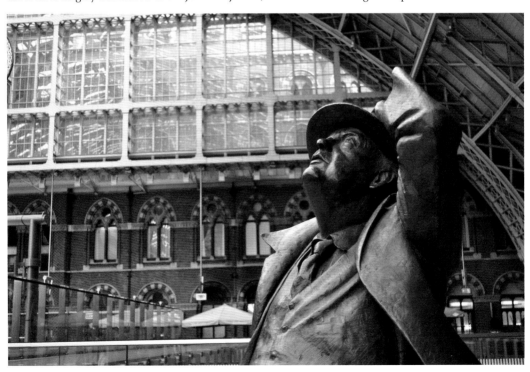

St Pancras

St Pancras was a relatively late addition to the collection of termini strung along the Euston Road. By the 1860s the Midland Railway (MR) was in an expansionist frame of mind and was frustrated with arrangements to run their trains into London on other companies' lines. As the new station would be sandwiched between the classicism of Euston to the west, with its imposing portico and booking hall, and the severe functionalism of King's Cross, its immediate neighbour, the directors decided that St Pancras should stand out from the crowd. The result was one of the most glorious railway stations to be found anywhere in the world with its vast single-span train shed fronted by the Midland Grand Hotel, a flamboyant display of Gothic that has been celebrated and derided in equal measure over the ensuing 150 years.

The main obstacle in bringing lines to the site was the Regent's Canal directly to the north. Next door at King's Cross this had been achieved by driving tunnels under the canal, but the MR's consulting engineer, William Henry Barlow, preferred to go over it. This meant that the station would be raised up by 17 feet above the Euston Road. Originally this was to be on an embankment, but it was realised that an undercroft would better serve the station to accommodate the thousands of beer barrels arriving by train from the Burton-on-Trent brewies. To support the floor of the train shed, a forest of iron columns was planted in a uniform grid with fifteen rows and forty-eight deep. In designing the roof Barlow had originally considered a twin-arched roof with a central support wall, but this was impractical with an Underground line running beneath the site. Working closely with fellow engineer Rowland Mason Ordish, he instead devised a single-span design consisting of twenty-five ironwork arches or ribs. These were sprung directly from the station level without buttresses, and to overcome the sideways thrust of the roof they were embedded in iron girders running from side to side of the building to form the floor. At the time of its construction this was the largest single-span structure in the world.

The station opened to the public with the first train – an overnight mail from Leeds – arriving 4.20 a.m. on 1 October 1868. It was only once the trains had started running that the company had the money to commence work on the Midland Grand Hotel. Sir George Gilbert Scott won the competition to design the hotel, which opened in 1873. It was heralded as the most modern in Europe and boasted many innovative features including hydraulic passenger lifts, but lacked enough bathrooms and the concrete floors made upgrading difficult. It was looking decidedly old fashioned when the London Midland & Scottish Railway (LMS) took it over and it closed for business in 1935. For many years British Rail used and abused it as offices and after the threat of demolition to both train shed and hotel was thwarted it was abandoned in the 1980s. Following the remodelling of the St Pancras International as the Eurostar terminal, completed in 2007, the hotel was reopened in 2011. A masterpiece reborn for the twenty-first century.

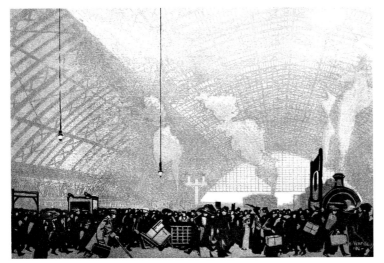

Top left: E. A. Verpilleux's wood engraving of the train shed at St Pancras. Published in *The Studio* in 1927, it perfectly captures the atmosphere of this great station in the days of steam.

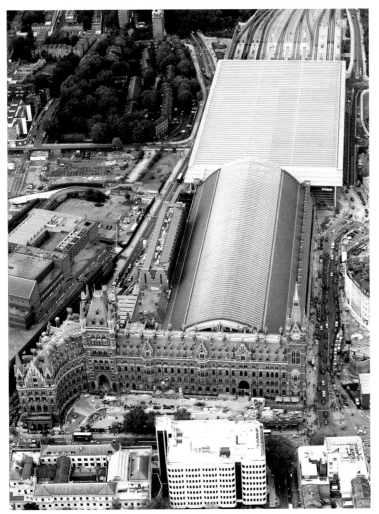

Lower left: Aerial view looking north, showing the station with rebuilding work still in progress on the hotel. At the top of the photograph is the flat roof of the station extension. To the left, the red brick of the British Library occupies most of the former goods yard site on the western side, and on the far right the curve of the Great Northern Hotel at King's Cross peeps into view. See page 47. *(Network Rail)*

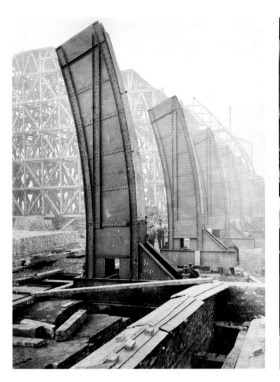

The train shed roof consists of twenty-five sets of wrought iron ribs made up of riveted sections and linked by a lattice of main and cross braces. *Above left*: The iron girders at the foot of each rib extended at deck level to connect the sides of the structure. *Above right*: A pair of girders, painted blue in the renovation, flank the entrance to the bar. *Below*: With the train shed completed in 1868, construction of the hotel commenced.

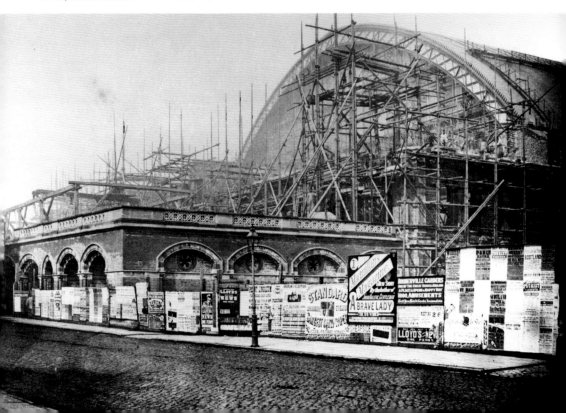

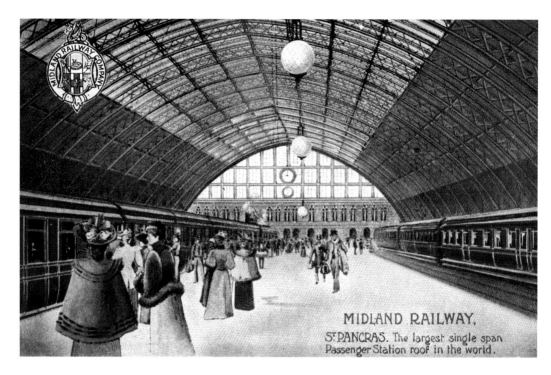

MIDLAND RAILWAY,
S! PANCRAS. The largest single span
Passenger Station roof in the world.

Above: 'The largest single span passenger station roof in the world.' Facing the hotel end, fashionable travellers are depicted in a Midland Railway postcard. *Below*: The station underwent a remarkable transformation into the modern St Pancras International, complete with Eurostar's high-speed trains. The modern glazed roof area replicates Barlow's original.

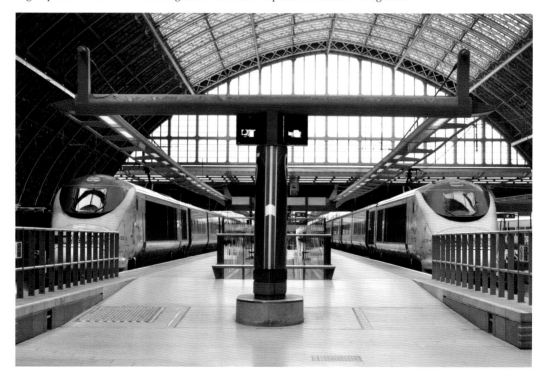

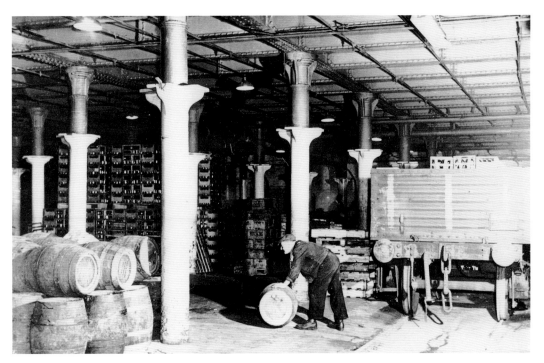

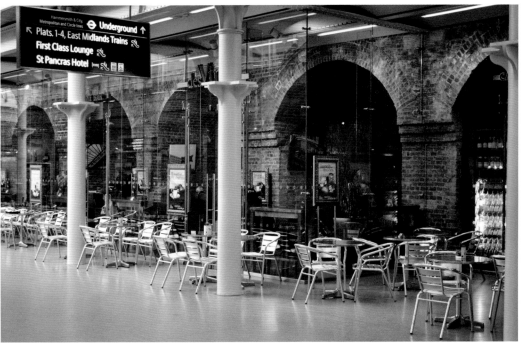

Above: A forest of iron columns supported the rail deck, which was 17 feet higher than the surrounding area. There were fifteen rows, fourteen deep, their spacing dictated by the dimensions of beer barrels from the Burton-on-Trent breweries. The redundant brackets or cleats near the top suggest that they were probably bought as off-the-shelf castings. Many of the columns, as well as the hefty side arches at the base of the walls, are visible in today's Arcade area.

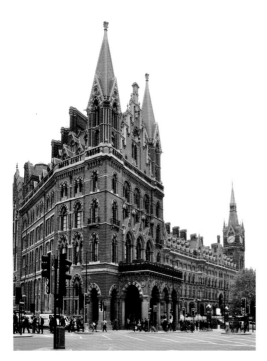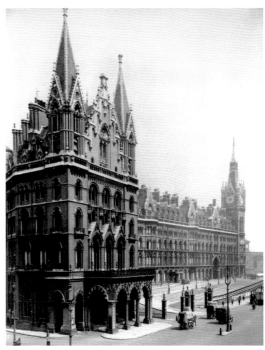

The Midland Grand Hotel

Above: Architect Sir George Gilbert Scott used steeply pitched roofs and multiple pinnacles to emphasise the height of the hotel, which was built on an awkwardly shaped site with a tapering west wing. *Below*: The portico on the Euston Road has survived intact. It had a narrow driveway for horse-drawn carriages to pull up to the original main entrance.

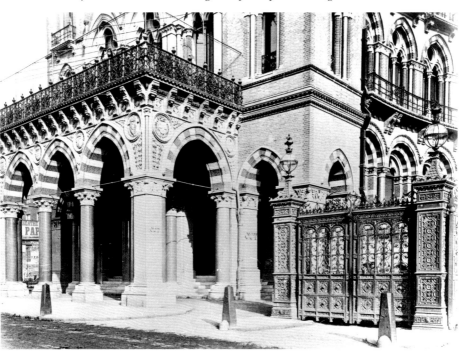

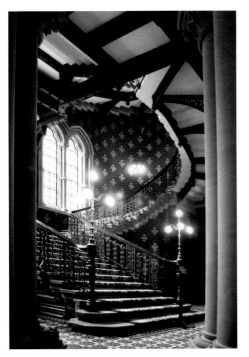

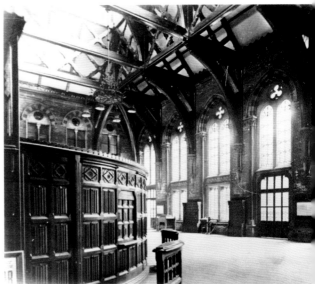

Above: The state-of-the-art 'raising room' elevator threatened to make the Grand Staircase redundant, but who could resist ascending on this collision between Victorian engineering and architecture? Scott's exposed ironwork, the girders and brackets, bequeathed a masterpiece that is more steampunk than Disney.

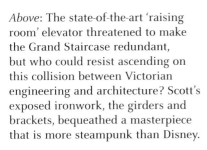

Top and middle right: The Booking Office has been transformed into a smart bar with its tall windows looking out on to the train shed. It originally featured a tall ceiling with roof lantern. The ecclesiastical atmosphere is emphasised by the linenfold panelling on the screen, which was pierced by confessional-like openings to the booking clerks. The exit to the platforms is on the left.

Bottom right: The Coffee Room followed the gentle curve of the front of the building and was dominated by a vast sideboard. Note the rich, darkly coloured wall coverings and decorative painted friezes.

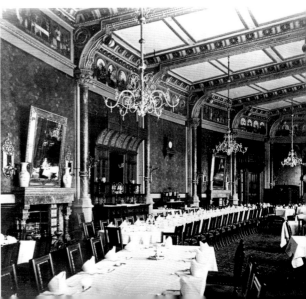

Pulling power

Above: In June 1948 LNER's No. 61251 *Oliver Bury* was photographed hauling the 10.15 Manchester express out of St Pancras, with the goods yard visible to the right. This is a 4-6-0, B1 class, on loan to the LMS as part of the British Railways Locomotive Exchange. *Below*: East Midland Trains HST No. 34060 pulling out of the new terminus in April 2012.

Top right: The new side entrance to the station on the King's Cross side indicates the end of the concourse area and the transition section linking the old train shed and the modern extension. This accommodates both the longer Eurostar trains and, on the western side, the domestic platforms for the East Midlands trains.

Middle right: The Somers Town Goods Depot occupied an area larger than the station itself, as shown in this aerial photograph from the 1930s. It handled over 1,000 tons of freight a day. The coal yards are at the bottom of the photograph.

Bottom right: A view of the Euston Road frontage of the Goods Yard, badly damaged by the bombing raids on London during the Second World War. The hotel is in the background.

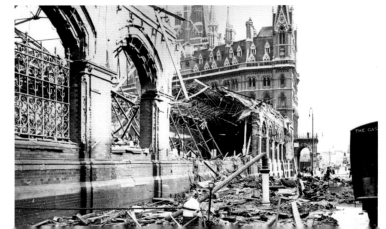

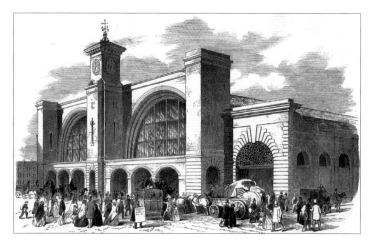

A bold design

Left: The façade of Lewis Cubbitt's station at King's Cross shown in an *Illustrated London News* engraving published shortly after its opening in 1852, and again in 2012 shortly before the remodelling of the area in front of the station. The twin lunettes reflect and reveal the roofs of the train shed within. On the right is the covered cab road beside Maiden Lane (York Way).

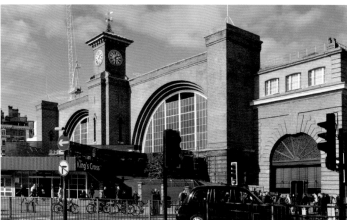

Below: This postcard shows the proximity of King's Cross to neighbouring St Pancras, *c.* 1905. Note the Tube station under construction at the front, plus assorted buildings and the canopy.

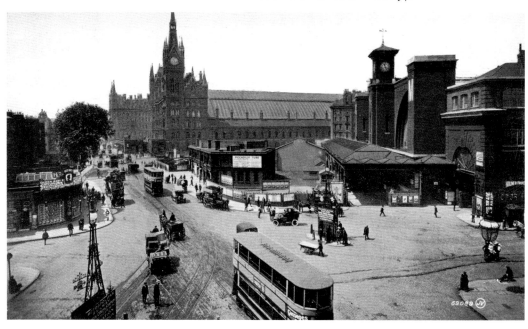

King's Cross

King's Cross dates from the mid-period of the railways' arrival in London, and some sixteen years before St Pancras. The area took its name from a short-lived monument erected in 1836 to honour the late king, and the land was mostly open fields although it did include the Smallpox Hospital, which was demolished to make way for the station. It was a less than ideal location as the Regent's Canal was only 600 feet from the end of the station and ran east–west 30 feet above the platform level. Sir William Cubitt was put in charge of designing the station and his solution was to build the Gas Works Tunnel under the canal. The architect for the station building was yet another Cubitt, this time Joseph, who produced a design for a double-span roof. 800 feet long, it was the largest station in the capital and was 100 feet longer than Brunel's New Paddington, which was being built at around the same time. Cubitt's spans were also wider and he bucked the trend by using laminated timber ribs instead of wrought-iron. King's Cross lacked the usual hotel frontage and the no-frills façade consists of a screen wall of London stock brick, divided vertically into two sections with each one pierced by large semicircular windows known as 'lunettes' to mimic and reveal the roofs within. 'The building will depend for its effect on the largeness of some of the features, its fitness for its purpose and its characteristic expression of that purpose,' claimed Cubitt. But the Victorians didn't know what to make of it. They weren't ready for the stark, simple lines that served as a refreshing foil to the prelevant sham Gothic that pervaded so many of London's buildings at that time.

When the main King's Cross opened – a temporary station had been erected in 1850 alongside the goods station to the west of Maiden Lane (now York Road) – it had only two platforms set against the outer walls and there was no concourse area as such at the end of the station. Over the years the station underwent several changes to increase capacity. Additional platforms were added in 1862, but it wasn't until 1893 that two further ones were built down the middle, necessitating the construction of the linking footbridge. Externally there were greater changes. The Metropolitan Railway opened in October 1863 with its own station to the east of the main station, and the Met's 'Widened Lines' – a stretch of track with two extra lines – was linked to the Great Northern Railway (GNR) by new underground connections. For local trains the York Road Platform opened in 1865 on the eastern side near the Gas Works Tunnel. In 1875 King's Cross (Local) opened in an annexe attached to the western side of the station, and King's Cross (Suburban) opened in 1878. The grouping of the railways brought King's Cross under the control of the London & North Eastern Railway (LNER), which also inherited Marylebone and Liverpool Street. King's Cross remained the principal terminus for the East Coast Main Line to Edinburgh, Aberdeen and Inverness. In recent times a £500-million refurbishment has successfully preserved the historic buildings by sensitively introducing the best elements of modern design including a spectacular new concourse area linking with the curve of the hotel.

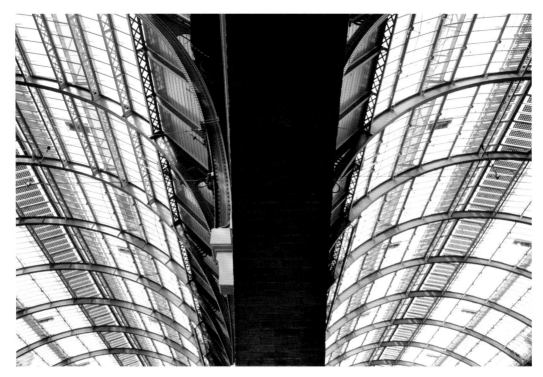

A new roof

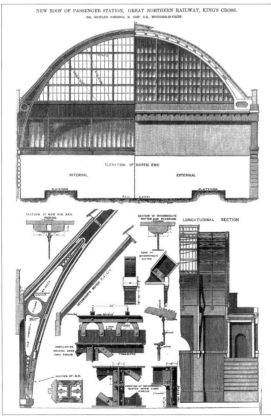

Above: The double-span arched roof was 800 feet long – 100 feet longer than Brunel's arches at Paddington. The main difference is that Joseph Cubitt favoured laminated timber ribs, spaced at 20-foot intervals.

Left: By the 1860s these were starting to deteriorate and they were replaced by iron ribs as shown in this 1870 illustration from *The Engineer*. The more recent upgrade has seen the installation of new glazing panels to bring the light pouring back into the old station.

50

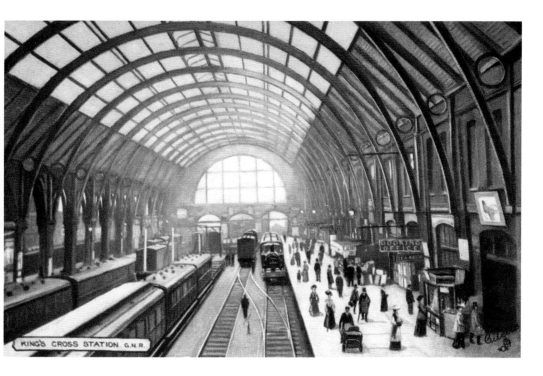

This postcard view from the GNR's heyday looks towards the town end of the western span. The departure platform is on the right with the entrance from the west side of the building through the booking office. In the 2012 photograph, *below*, the platform has been de-cluttered. The grey livery of the East Coast trains makes it feel very monochromatic.

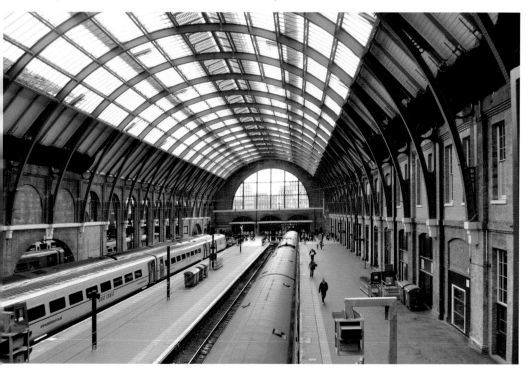

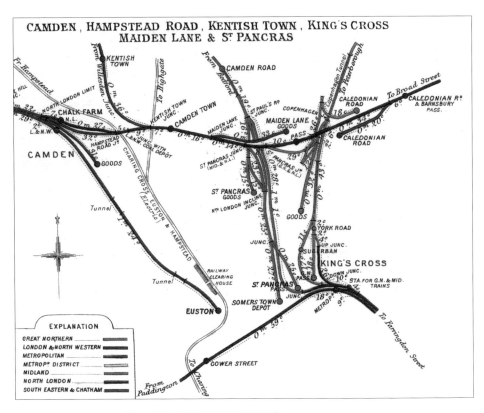

CAMDEN, HAMPSTEAD ROAD, KENTISH TOWN, KING'S CROSS MAIDEN LANE & S. PANCRAS

EXPLANATION

GREAT NORTHERN
LONDON & NORTH WESTERN
METROPOLITAN
METROP. DISTRICT
MIDLAND
NORTH LONDON
SOUTH EASTERN & CHATHAM

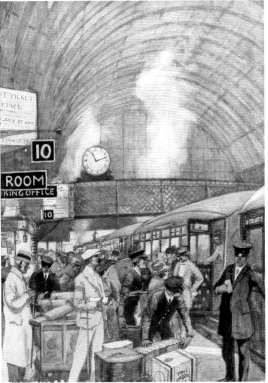

Above: A 1903 railway chart showing the proximity of the lines into St Pancras, shown in green, and the GNR line into King's Cross, in brown. The Metropolitan Railway, which is shown in dark brown, follows the line of the Euston Road.

Left: A fine period illustration of the Departures Platform with the 1893 iron Handyside footbridge with clock in the background. The bridge was dismantled in 2009 and donated to the Mid Hants Railway. The new modern bridge provides access via escalators and lifts. King's Cross was also the departure point for fashionable passengers heading to Scotland on the East Coast route for the shooting season.

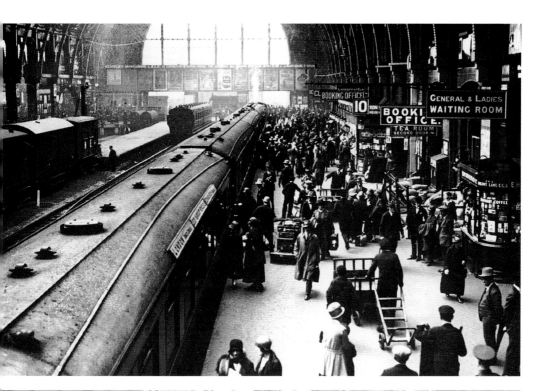

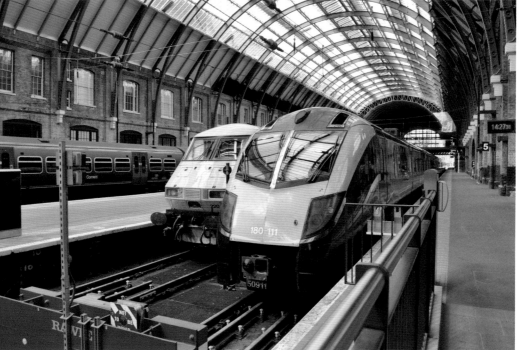

Top: A platform crowded with travellers, railway porters and several kiosks and bookstalls from the early LNER days. The booking office and waiting room are to the right. *Bottom*: An East Coast ex-BR Class 91 electric loco waiting beside a Grand Central Class 180 Adelante diesel multiple unit.

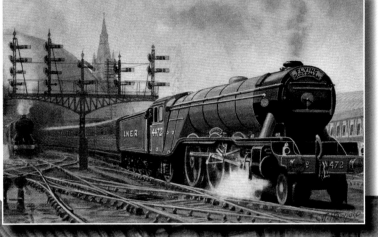

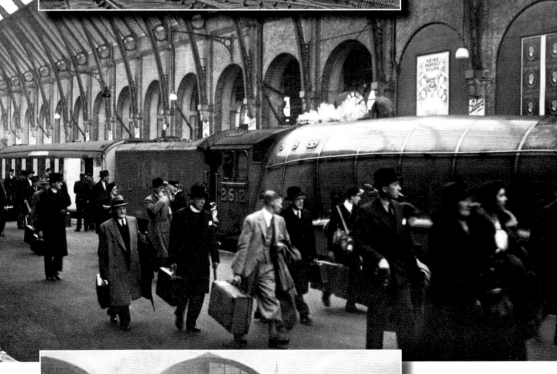

Top: The Flying Scotsman, departing with the St Pancras tower in the background.

Middle: The A4 Pacific, *Silver Fox*, built for the Silver Jubilee service.

Bottom: 'Morning rush-hour from King's Cross to the North.'

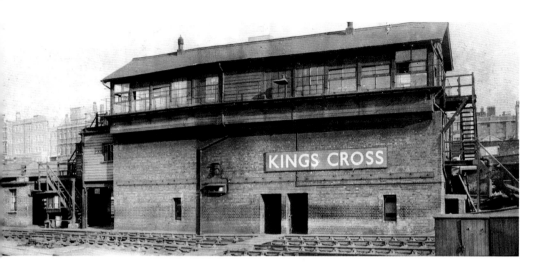

Above: The King's Cross signal box, *c.* 1960. The new signal box, completed in 1977, stands at the northern end of the old York Road Platform.

Right: Looking from the main platforms across to York Road on the eastern side of the lines.

Below: The triple bores of the Gas Works Tunnel, which passes under the Regent's Canal.

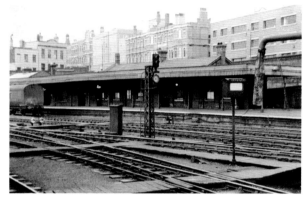

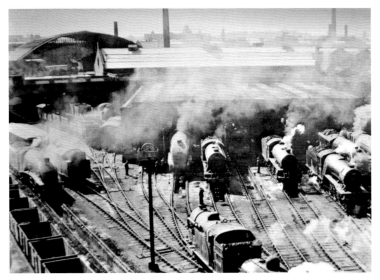

The Goods Yard and Running Shed
Left: A 1950s photo taken from the coaling tower looking down on a busy Running Shed with the original GNR 1850 Locomotive Hall behind, and St Pancras in the background.

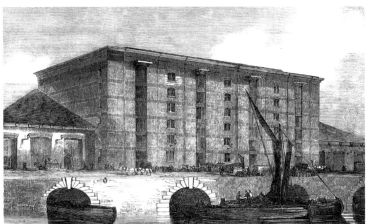

Middle left and bottom: Lewis Cubitt's six-storey Granary, with openings for hoist access at the front, and set slightly back on either side are the two main Goods or Transit Sheds. Access tunnels led to a basin at the front of the building, now filled in.

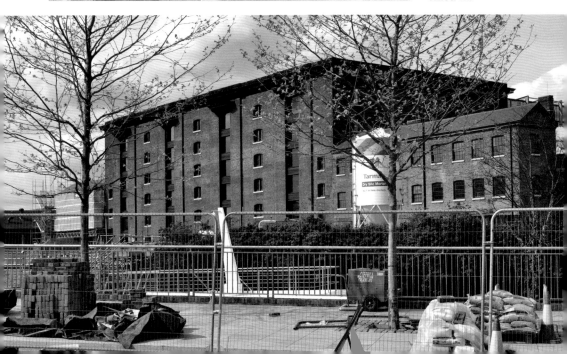

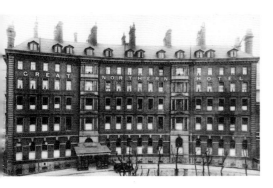
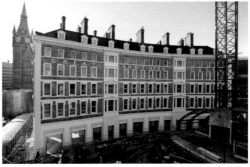

Change at King's Cross
Above: Once faced with demolition, the Great Northern Hotel has been refurbished and incorporated within the new station concourse. The hotel was built on a curve to follow the line of the road. It is shown on the right in 2009 during construction work. *(John Sturrock/King's Cross Central)*

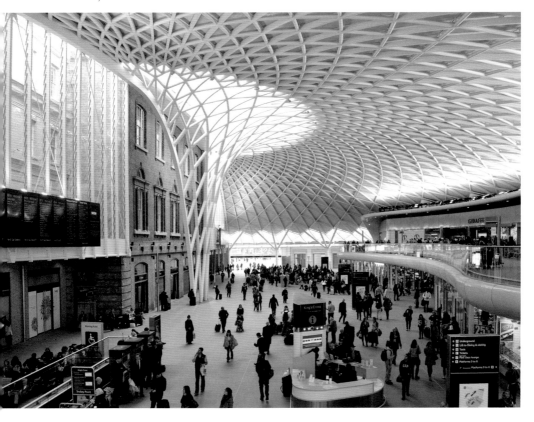

Above: The spectacular roof of the new Western Concourse erupts from the station wall like a cascade of steel and glass and flows into the curve of the hotel building. The concourse is designed to cope with around 100,000 passengers passing through at peak times. Designed by John McAslan, the intricate structure of 1,200 solid and 1,012 glass panels changes colour almost imperceptibly. The result is spectacular. In its reborn form King's Cross has managed to retain its strong individuality and has its architectural integrity intact. It has finally emerged from the shadows of St Pancras.

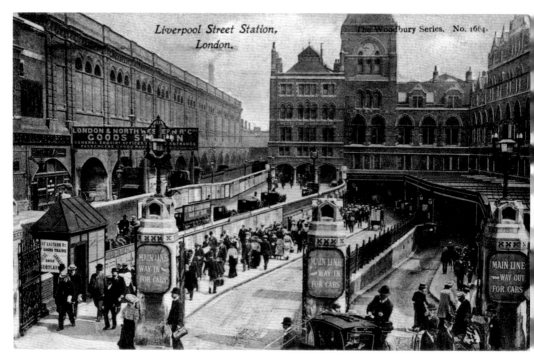

Liverpool Street Station, London. The Woodbury Series. No. 1664.

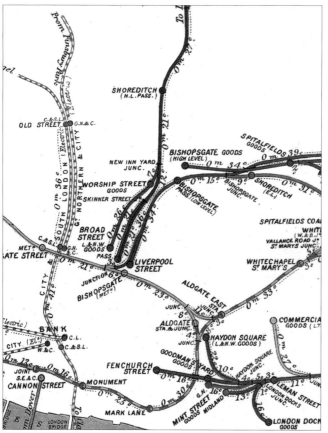

The GER's terminus

Top: The approach into the split-level station, *c.* 1910.

Above: The GER's crest incorporates the shields of Maldon, Ipswich, Norwich, Cambridge, Hereford, Northampton, Huntingdon and Middlesex, with London at the centre. *(Oxyman)*

Left: A railway chart, *c.* 1904, showing the lines coming in to Broad Street and Liverpool Street stations on the north-east side of the City.

Liverpool Street

Located on the north-eastern corner of the City and opened in 1874, Liverpool Street station was a replacement for the Great Eastern Railway's (GER) main terminus at Bishopsgate, which was subsequently converted into a goods yard. Betjeman describes Liverpool Street as 'the most picturesque and interesting of the London termini'.

The GER had been formed through a merger of several companies and the directors were determined to make an impact with the new terminus. The station was built on a 10-acre site adjacent to the Broad Street station, west of Bishopsgate. Its designer was the GER's engineer Edward Wilson, with the roof designed and constructed by the Fairburn Engineering Company. In general the station buildings were in the Gothic style using London stock bricks and limestone dressings, and they incorporated booking offices as well as the company offices. The roof consisted of four wrought iron spans, with two central spans of 109 feet and two outer ones of 46 and 44 feet, and these were 730 feet in length over the main lines and 450 feet long for the local platforms. There were ten platforms with two for mainline trains and the remainder for the suburban services. The Metropolitan Railway had its own facilities at a lower sub-ground level initially until their own underground station opened in 1875.

In 1890 work began to the east side to expand the station by the addition of eight new platforms to meet the increasing demand. The new station was covered by a series of four arched roofs, and at the north end an elevated parcels office was constructed over the tracks. Almost a hundred years later the station underwent a major modernisation in the 1980s. This retained the 1875 western roof and saw repairs to the main roof, but also the Broadgate development with construction of new offices and shops on the site of the Broad Street station (closed in 1986).

Under the Grouping of 1923 the station came under the control of the LNER, but it was suffering a steady decline by the wartime years and was unpopular for its confusing and disjointed layout. Fortunately Liverpool Street has seen massive improvements since then and its close proximity to the City, Shoreditch, the Barbican and Whitechapel has ensured that it remains one of London's busiest termini. Today the station serves the West Anglia Main Line to Cambridge, and the Great Eastern Main Line to Norwich, in addition to local and commuter trains to destinations east of London including the Stansted Express to the airport.

The Great Eastern Hotel, on a hill adjoining the station, was completed in 1884. Built in red brick, it was designed by the brothers Charles Barry and Edward Middleton Barry in a jumble of styles best summed up as French Renaissance. Once described as the best hotel in London, it was notable for the inclusion of two Masonic temples – an Egytian temple in the basement and a Grecian temple on the first floor – and has seen several expansions. Since 2006 the hotel has been owned by Hyatt and now operates as the Andaz Liverpool Street London.

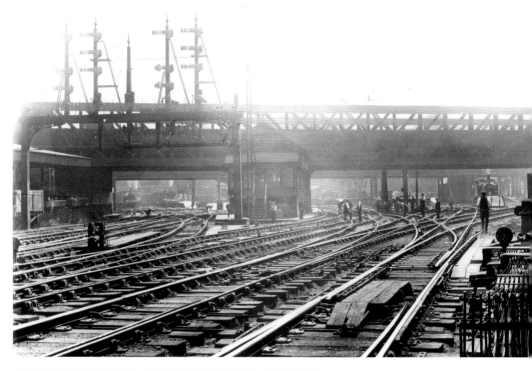

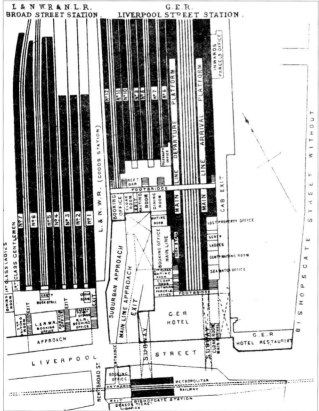

Above: Men at work on the lines going into Liverpool Street station, showing the West Side signal box, *c.* 1919.

Left: An interesting plan from the 1888 *District Railway Guide to London.* It shows the arrangements and individual scale of the two stations side by side, Broad Street for the London & North Western Railway as well as the North London Railway and Liverpool Street for the Great Eastern Railway. The Great Eastern Hotel can be seen on Liverpool Street beside the suburban and main line station approaches for passengers.

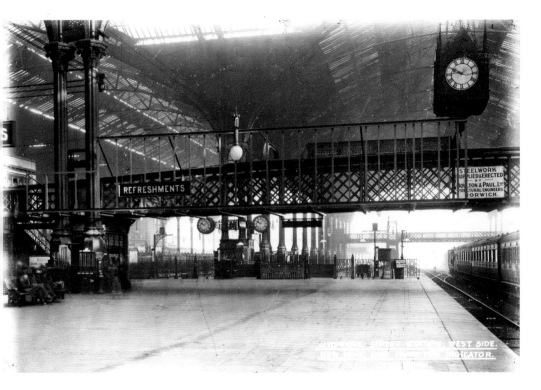

Above: The West Side of Liverpool Street station, photographed in 1922, showing a steel framework in place for a new main line train indicator. Note the footbridge, also shown below in this recent photograph of the train shed. *(Steven Vance)*

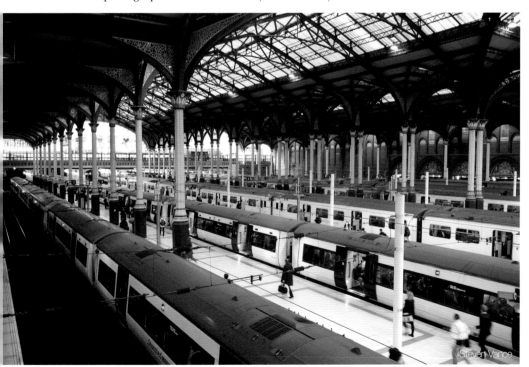

Top left: Taken in 1921, a photograph showing the new enquiry office on Platform 9.

Middle left: The memorial for more than 1,000 of the GER's employees who died in the First World War. On 13 June 1917 the station was badly damaged in a daylight raid by Gotha bombers, which killed 162 people and injured 432.

Below: Sunshine pours into the main concourse at Liverpool Street station in 2007. *(Alex Leceq)*

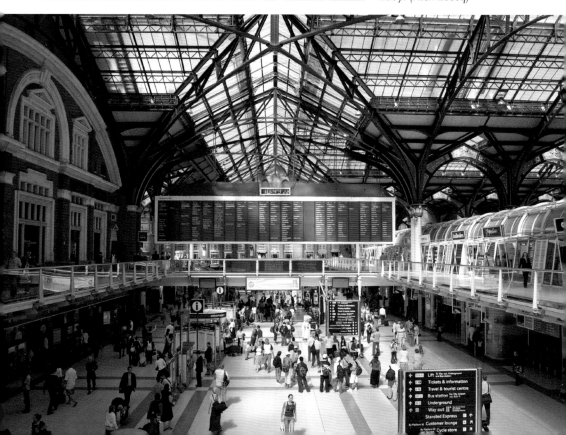

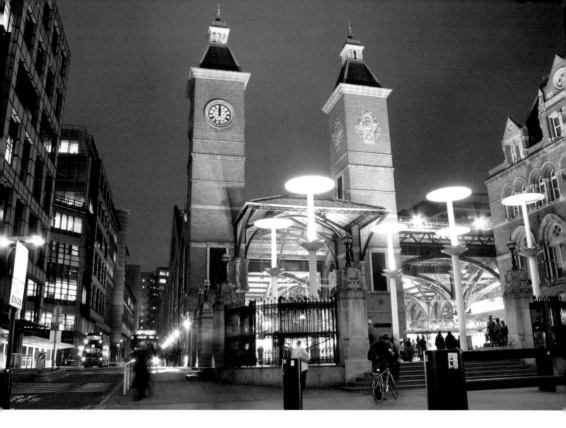

Above: Twin towers at the modern entrance into Liverpool Street, 2010. *(Andrea Vail)*

Below: Broad Street station opened in 1865 as the main terminus for the North London Railway's suburban services. It closed in 1986 due to diminishing passenger numbers.

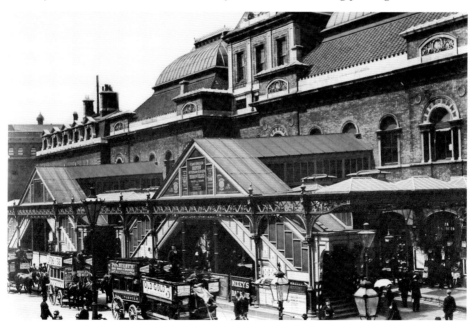

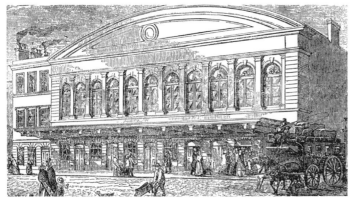

Above: An illustration of the station at Fenchurch Street following the rebuild, which was completed in 1853. The line ran on a series of viaducts to cross the various waterways and so the platforms are up on the first storey.

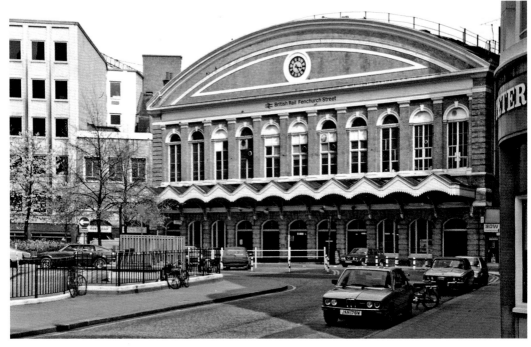

Above: The station photographed in the 1980s. Little has changed since then apart from the encroachment of surrounding developments.
(Ben Brooksbank)

Left: A Southend train waiting to depart from Platform 3.

Fenchurch Street

This 'station in the City' was completed in 1841, a year after the rest of the London & Blackwall Railway had opened. (Until then the terminus for the line had been at the Minories, a little to the east.) The original station building had a simple two-storey frontage. On the ground floor were five entrances, topped by semicircular segmental arches, leading into a booking hall. The upper windows gave light to the end of the train shed, which had just two platforms accessed via stairways ascending from the booking hall. The L&BR's engineer, Robert Stephenson, utilised the rope-hauled system also used for the Camden Incline at Euston for this line. Because Fenchurch Street was to the west of the Minories' winding gear, incoming trains were released from the rope at Minories to cruise into the station under their own momentum. Outgoing trains needed to be pushed by railway personnel until they began to roll down the slight incline to Minories. Steam locomotives were not introduced on the line until 1849.

An increase in traffic brought about the rebuilding of the terminus and this was completed in 1853. Fenchurch Street now had four platforms beneath an iron and glass roof 300 feet long and with a graceful arched span of 101 feet. The new façade was far grander than its predecessor with eleven bays on the ground level, each with a tall round-topped window. The whole was capped by a wide semi-circular pediment. John Betjeman once described Fenchurch Street as a 'delightful hidden old terminus', but sadly, his statement that it 'has been less messed about than any London terminus' no longer holds true. Its old charms have been swept away; the great passenger roof – under which Betjeman would depart on day-return trips on the old London Tilbury & Southend Railway for afternoon tea beside the sea in Southend – has disappeared, replaced by an office block erected in the 1980s. All that remains is the façade and even that is pressed in on all sides. In recent years the Docklands Light Railway has been built on much of the old L&BR line, including the many brick viaducts, but with Tower Gateway as the terminal plus a spur to Bank. One final note on Fenchurch Street; it is the only one of the capital's major termini not on the London Underground network.

Below: Detail from an 1890 map showing the L&BR line from Fenchurch Street, on the left, going as far as West India Docks station. Blackwall is off the edge to the right.

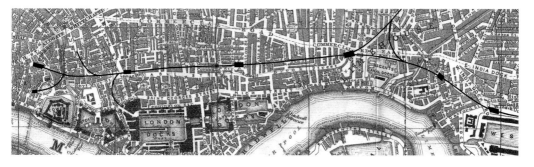

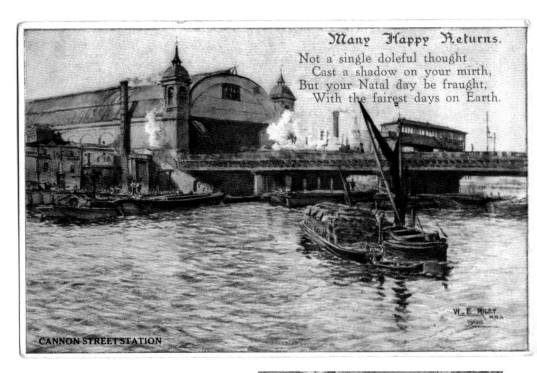

Many Happy Returns.

Not a single doleful thought
Cast a shadow on your mirth,
But your Natal day be fraught,
With the fairest days on Earth.

CANNON STREET STATION

W. E. RILEY

Cannon Street

A postcard of the station, above, with its original roof, the signal box and the bridge. Frank Brangwyn's atmospheric etching of the station seen from a barge is shown right. As shown below, the station retains its two towers but the station roof has been replaced by a modern structure.

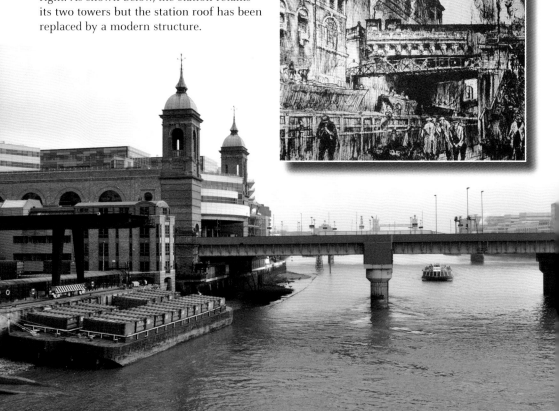

Cannon Street

Opened by the South Eastern Railway (SER) on 1 September 1866, the station was designed by John Hawkshaw and J. W. Barry. Two slender towers – designed to blend in with Sir Christopher Wren's City steeples – looking out onto the Thames flanked a 700-foot-long train shed covered by a sinle arch of wrought iron and glass. The following year the station was joined by an Italianate-style hotel designed by Barry to provide the station with an imposing architectural frontispiece, much in the vein of the hotel at Charing Cross. Originally called the City Terminus Hotel, it became the Cannon Street Hotel in 1879.

The approach by rail over the Thames to Cannon Street is over the Cannon Street Railway Bridge – designed by Hawkshaw Barry, it was the eastern-most of the Thames railway crossings – via a triangular connection to both London Bridge and Charing Cross. It originally had eight platforms, although a refurbishment in the late 1990s saw the removal of the original Platform 1. From 1923 the station came under the control of the Southern Railway (SR), who used the hotel for offices. Some works, including rebuilding the platforms, relaying the tracks and installing a new system of electrical signalling were carried out. They also renovated the station and cleaned the roof.

Prior to the Second World War the glass roof was removed and put into storage to protect it but, ironically, the factory in which it was stored was badly bombed and the roof was lost. From the 1950s onwards there was the customary talk from British Railways (BR) of redeveloping the station and various plans were mooted. In 1958 the remains of the roof were removed, and two years later Barry's hotel was demolished. The controversial architect John Poulson won the contract to design a new modern office block. (Poulson was later convicted of corruption charges in his dealings with railway officials.) By the 1980s BR began looking at the potential redevelopment of Cannon Street and the air rights above the platforms were covered by office blocks suspended on a 6,000-tonne steel deck. In 2007 planning permission was granted to replace the Poulson building facing on to the road and a £360-million project has seen Cannon Street transformed by a mixed-use development of office and retail space, including new entrances and booking hall for the station. Cannon Street won the award for 'Large Station of the Year' at the 2013 National Rail Awards.

Little remains of the old Cannon Street station, just the twin 120-foot brick towers and parts of the flanking walls. Managed by Network Rail, mainline services are operated by Southeastern, serving destinations in south-east London and Kent. There is also an Underground station on the Circle and District lines. The original railway bridge has faired little better. It was widened between 1886 and 1893, and extensively 'renovated' by British Rail between 1979 and 1982, entailing the removal of most of its ornamental features. In 1989 it was the scene of the *Marchioness* disaster when two rivercraft collided, resulting in the deaths of fifty-one people.

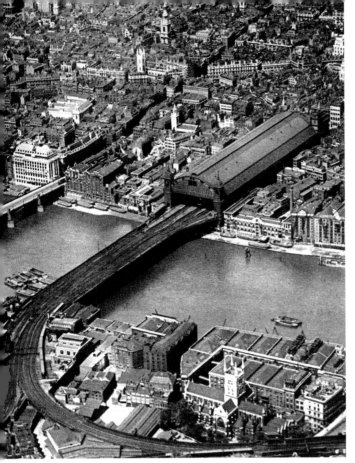

Left: A striking aerial photograph from the 1930s showing the lines which span the Thames to link Cannon Street with the south side of the river. At that time it was one of the Southern Railway's six termini in London. The signal box is now positioned at the base of the lefthand tower. The east tower contains a water tank.

Shown below is a British Railways Southern leaflet displaying the Poulson development for Cannon Street. The train shed roof was removed in 1958 and Barry's hotel came down two years later to make way for the Southern House office block. In 2007 planning permission was granted to replace the Poulson block with a new mixed-use building designed by Foggio Associates. The result, shown opposite, won the award for 'Large Station of the Year' at the National Rail Awards 2013. *(Network Rail)*

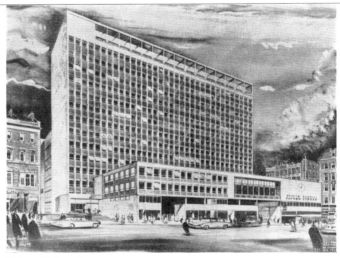

BRITISH RAILWAYS
SOUTHERN

This will be the new
CANNON STREET STATION
London's first big rail terminal of the sixties.

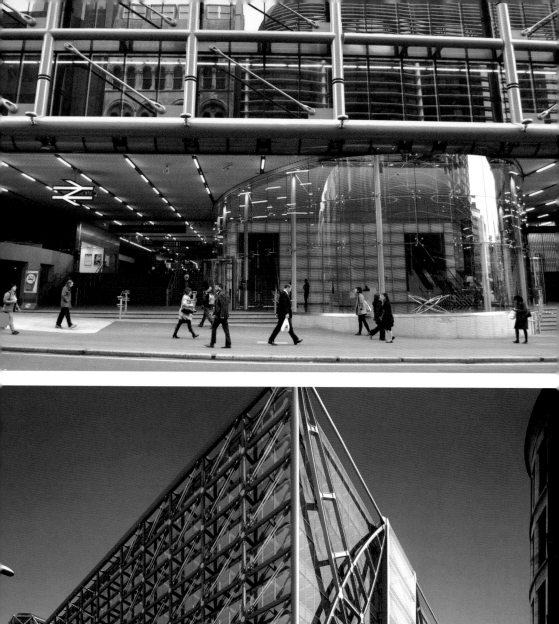

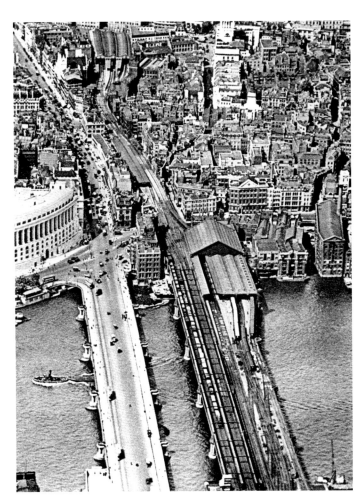

Three stations and three bridges

Below: A fascinating aerial photograph of the bridges and stations at Blackfriars, taken in the 1930s. From left to right are the Blackfriars Road Bridge, the original rail bridge of 1864 and the later rail bridge of 1886. The station on the north bank is St Paul's, which changed its name to Blackfriars station in 1937. Continuing northwards there is Ludgate Hill station and, at the end of the line, Holborn Viaduct station. The chart on page 72 helps to clarify this layout.

Below: This recent photograph shows the road bridge, the columns that supported the 1864 rail bridge and the later bridge with the rebuilt Blackfriars Station extending along its full length. The roof is covered with over 4,000 solar panels. *(Network Rail)*

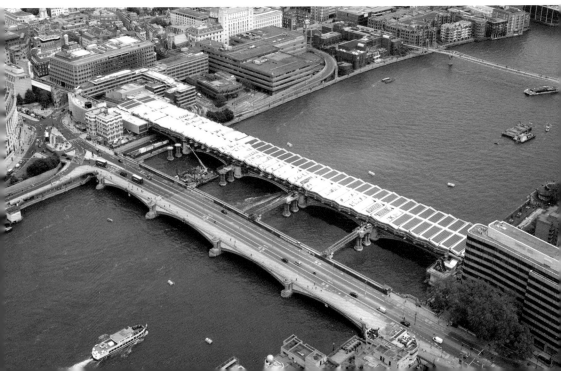

Blackfriars

If Victoria had a split personality, then it is fair to say that Blackfriars had multiple personality issues as the name of the station and its associated bridge has been shifted around over the years. (The old and new aerial photographs shown on the opposite page may help to clarify matters.)

Blackfriars Bridge station was opened on on the south bank of the Thames on 1 June 1864 by the London, Chatham & Dover Railway (LCDR) as the terminus of its City Line, albeit briefly. It featured a two-level building which combined both goods and passenger operations, with hydraulic lifts to raise the goods wagons between the levels. It had three passenger platforms with through lines crossing the river to Ludgate Hill station on the north side via the original Blackfriars Railway Bridge. It was designed by Joseph Cubitt with the rail deck supported on triple clusters of iron colmns. (This is the middle of the three bridges and the columns, painted red, plus some of the intricate insignia panels for the LCDR still remain in situ.) Once Ludgate Hill station was opened in December of 1864 the Blackfriars Bridge station was closed to passengers, although the building was retained as a good depot until it closed completely in 1964.

Holborn Viaduct station was opened in 1874 to alleviate the usage of Ludgate Hill. The second rail bridge, to the east of the first and designed by John Wolfe-Barry, was completed in 1886 with a new station on the north bank originally called St Paul's station. This name was retained until 1937, when it was renamed by the Southern Railway as Blackfriars to avoid confusion with the renamed St Paul's Tube station, and the 1886 rail bridge became the Blackfriars Railway Bridge. As the original 1864 rail bridge was becoming too weak for the heavier modern trains, it was closed in 1971 and the rail deck was removed in 1985, leaving the columns supporting thin air. Holborn Viaduct station was closed by British Rail five years after that.

Blackfriars was rebuilt by BR in the 1970s and renovated between 2009 and 2012. The existing office building was demolished and replaced as part of the Thameslink scheme and shares a ticket hall with the Underground station. The old platforms were removed and the through platforms were extended across the length of the bridge with a second booking hall on the south side of the river at Bankside. The rail deck was widened on the western side and this station on a bridge is covered by a new roof, which in turn has been clad with over 4,400 photovoltaic solar panels to meet 50 per cent of the station's energy requirements. Blackfriars is the only station with entrances on both sides of the river and the additional and extended platforms will see a doubling of train services by 2018.

While the old Blackfriars in its various forms has been lost, the new covered station has become a distinctive addition to London's skyline as well as being the world's largest solar-powered bridge. The nearby road bridge, confusingly the Blackfriars Bridge, provides an excellent platform from which to see and photograph the bridge/station.

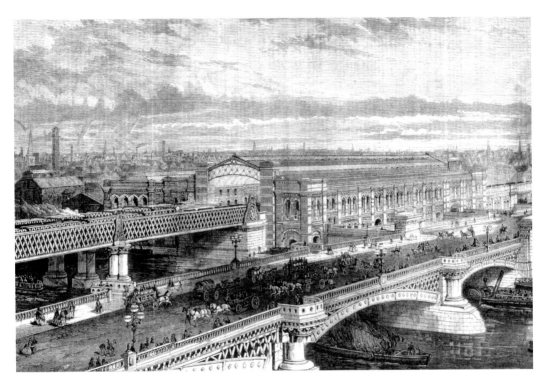

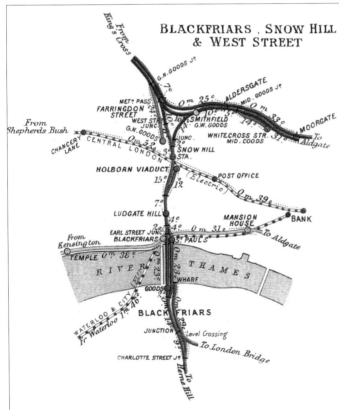

BLACKFRIARS, SNOW HILL & WEST STREET

Above: An engraving from *The Illustrated London News* of 1863 showing the newly constructed Blackfriars Bridge station on the south bank.

Left: A railway chart of *c.* 1904 showing the lines.

Below: Gustave Doré's depiction of the viaduct at Ludgate Hill in 1872.

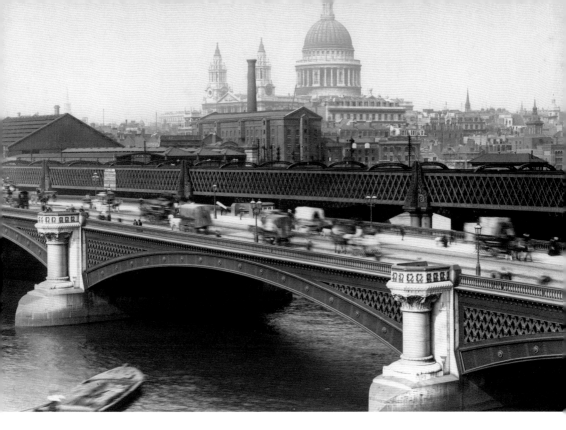

Above: A view looking across towards the cathedral with the road bridge in the foreground and the two rail bridges behind. St Paul's station (renamed Blackfriars) is on the left. *(LoC) Below*: These iron columns had supported the 1864 railway bridge, which was dismantled in 1985.

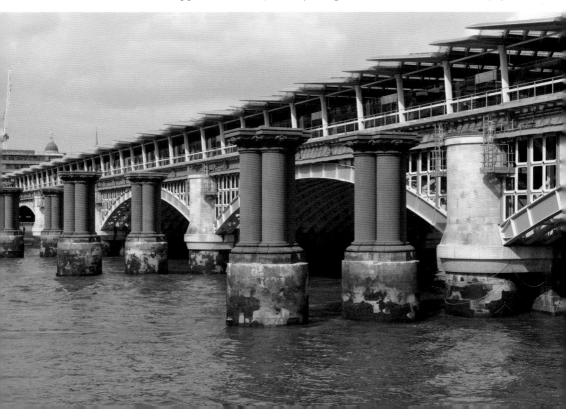

Above: Photographed before the recent rebuild as part of the Thameslink programme, this was the simple roof at Blackfriars station. The columns have gone to the Pontypool & Blaenavon heritage railway. *(Network Rail) Below left*: The columns and the new station seen from the road bridge. *Bottom right*: Installing the solar panels on the roof. *(Network Rail)*

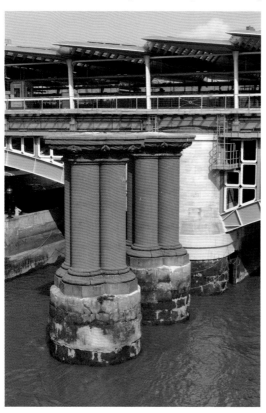

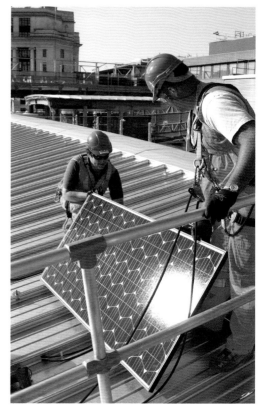

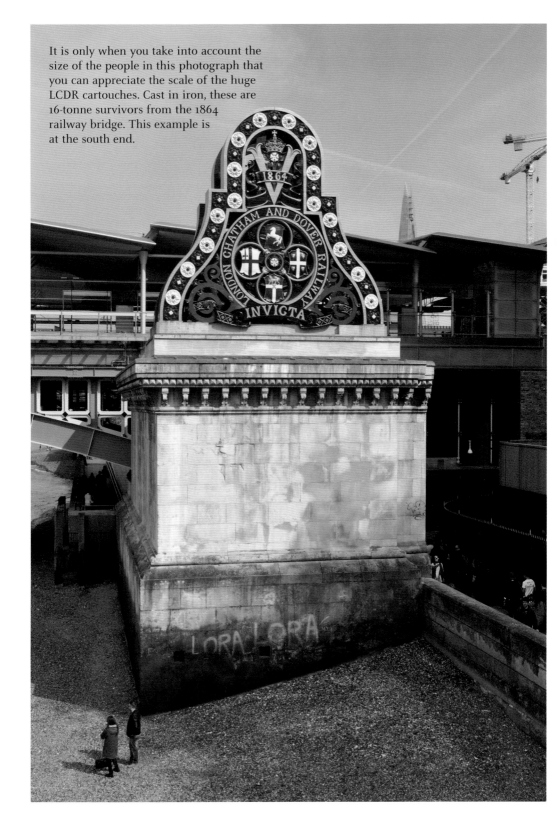

It is only when you take into account the size of the people in this photograph that you can appreciate the scale of the huge LCDR cartouches. Cast in iron, these are 16-tonne survivors from the 1864 railway bridge. This example is at the south end.

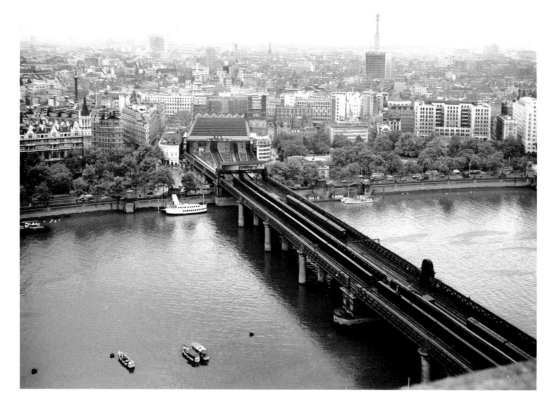

Charing Cross

Two views of Charing Cross and the railway crossing, before and after the rebuilding of the station and the addition of the Golden Jubilee Footbridges to either side of the bridge. The upper image is from the early 1950s, and the lower one is taken from the London Eye in 2005.

Charing Cross

Charing Cross is often cited as being the centre of London, a datum point marked by the Eleanor Cross from which distances are measured. The station stands on the end of the once-fashionable Strand and looks out onto the edge of Trafalgar Square. It was built on the site of the Hungerford Market, which was sold to the South Eastern Railway in 1862. The old market was demolished and the footbridge to the south bank, a suspension bridge built by Brunel, was dismantled to leave only the footings. The station was designed by Sir John Hawkshaw, with a single-span wrought iron roof 164 feet wide covering six platforms. It opened on 11 January 1864 and the Charing Cross Hotel, by Edward Middleton Barry, opened fifteen months later. Although it looks far older, the Eleanor Cross located on the hotel forecourt is actually a replica based on the thirteenth-century Whitehall Cross and designed by Barry contemporary with the hotel.

On 5 December 1905 disaster struck when two bays at the end of the Hawkshaw's roof collapsed. It had been undergoing repairs when the girders and debris fell across four passenger trains standing at the platforms, killing six people. The neighbouring Avenue Theatre was also damaged. In the aftermath the station was closed for over three months and the railway company decided to remove the remainder of the roof and replace it with a more utilitarian design featuring a post and girder structure supporting a ridge and furrow roof. In 1990 this too was removed, to be replaced by Embankment Place, an office and shopping complex, leaving only the rear two spans of the 1906 structure adjacent to the rear of the hotel. Today Charing Cross station serves the South Eastern Main Line with trains operated by Southeastern.

Below: British Railways' plan of the station published in the 1960s.

CHARING CROSS STATION
SOUTHERN REGION
BRITISH RAILWAYS

KEY TO RUNNING LINES

DL ..	Down Local	UL ..	Up Local
MR ..	Middle Road	DT..	Down Through
	UT..	Up Through	

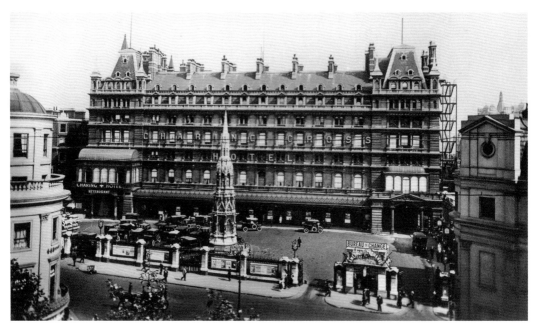

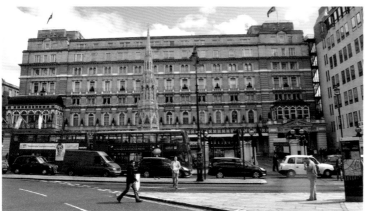

'Gateway to the Continent'

Above and left: The exterior of the 1865 Charing Cross Hotel with the replica Eleanor Cross in the forecourt. The Portland stone cross was designed by E. M. Barry when the hotel was constructed. It was based on the Whitehall Cross demolished in 1647. Apart from changes to the roof, the exterior of the hotel has little changed over the years.

Bottom left: The Eleanor Cross has undergone an extensive ten-month restoration, which was completed in 2010. *(Network Rail)*

Right: Charing Cross was built on the site of the Hungerford Market, which was sold to the South Eastern Railway in 1863. This engraving shows the demolition of the market. Opened in 1833, the market had lasted for only nineteen years and was in commercial decline by the 1850s.

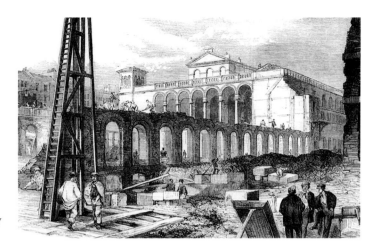

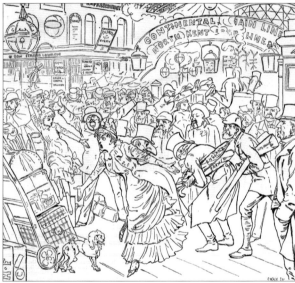

Above left and right: Continental travellers at Charing Cross in Edwardian times. The cartoon from an 1885 edition of *Punch* depicts something of the chaos. 'Abandon hope – of calm ease – whoever its labyrinth enters.'

Right: Little remains of the old station building apart from this area of the interior and a short section of the roof.

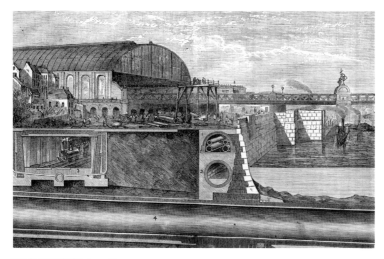

Top left: The Victoria Embankment in the 1860s extended the northern shoreline of the Thames into the river to accommodate new sewage pipes and the Underground railway.

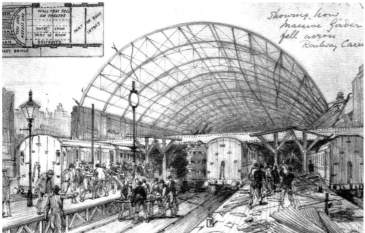

Left: Disaster struck at Charing Cross on 5 December 1905 when a 77-foot section of the roof collapsed, killing six.

Below: A view looking into the station from the bridge, showing the replacement ridge and furrow roof. The station had reopened on 19 March 1906.

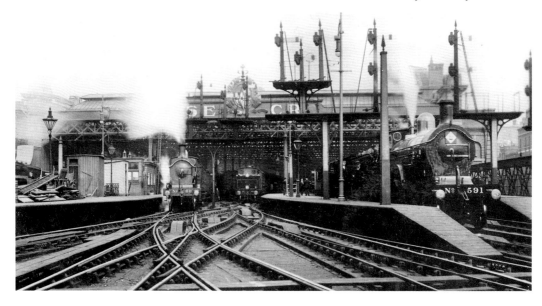

Brunel's footbridge, shown right, connected Hungerford Market with the South Bank. Opened on 1 May 1845, it had a main span of 676 feet. When the market site was sold to the railway a new girder bridge, designed by John Hawkshaw, was built on the original footings to carry the railway. These are shown below along with the Golden Jubilee Footbridges.

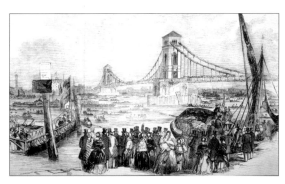

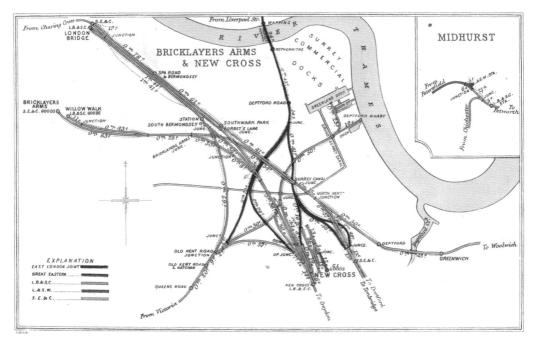

London Bridge

Above: A railway chart showing the straight line of the viaduct carrying the London & Greenwich Railway, plus the location of the Bricklayer's Arms and the later connection (in red) going under the Thames through Marc Bunel's tunnel.

Left: The original station for the L&GR, which opened in 1836, before the roof was erected.

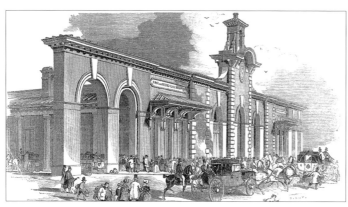

Bottom left: Lewis Cubitt's façade for the Bricklayer's Arms, built by the South Eastern Railway to avoid the excessive charges the L&GR imposed for their use of its lines.

Opposite page: The proposed London Bridge joint station, *c.* 1844.

London Bridge

Opened in 1836 for the first London railway, which ran to Greenwich on a ribbon of brick arches, London Bridge was once described as 'the most complicated, muddled and unwelcoming of London termini' with its narrow platforms and confusion of footbridges and passages. It is a description that few travellers would recognise nowadays as the station has been extensively rebuilt.

London Bridge station has had many incarnations. The original was built by the London & Greenwich Railway (L&GR) with a timber roof but, strapped for cash, they sold some of the adjacent land to the proposed London & Croydon Railway. Meanwhile, Parliament decided that the London–Greenwich line should also be the corridor into the capital for the London & Brighton Railway and the South East Railway (SER) and granted powers for the L&BR to enlarge the station it was constructing. The approach viaduct was enlarged, and the railway companies swapped stations to avoid crossing each other's lines, with the first station demolished for a new joint one serving the Croydon, Brighton and South Eastern companies. Then the South Eastern and the Croydon companies gained approval for a line to a new station at Bricklayer's Arms, opened in 1844, leaving London Bridge to the Brighton and Greenwich companies. In 1846 the Brighton campanies merged with others to become the London, Brighton & South Coast Railway (LBSCR), which used the unfinished joint station until it was demolished in 1849 to make way for an enlarged station. The SER rebuilt and enlarged the second L&GR station and London Bridge remained their London terminus until 1864 when the station was rebuilt again as a through station. These alterations and rebuilds continued well into the twentieth century, until the 1923 Grouping put the whole lot into the hands of the Southern Railway. Further updates took place and in 2013 work commenced on a major transformation with new longer platforms and a rebuilt concourse as part of the Thameslink programme.

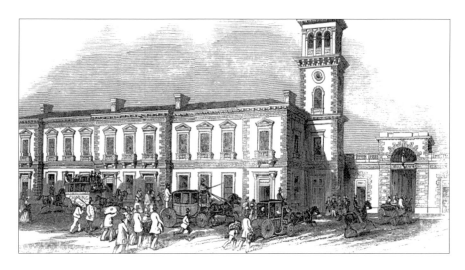

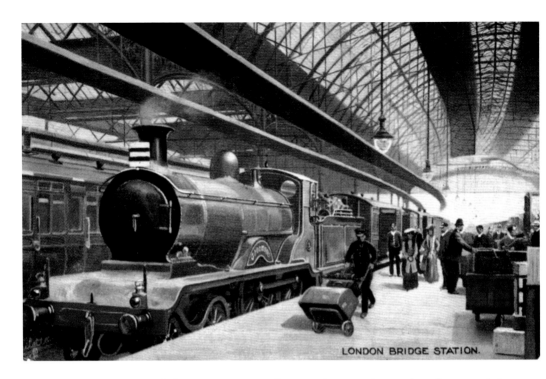

LONDON BRIDGE STATION.

Above: A colour postcard of the station, *c.* 1905, showing the curved central roof span and the LBSCR B4 class locomotive No. 71, *Goodwood*, in the company's distinctive brown livery. *Below*: The roof detail is shown again in this post-1923 photograph looking towards the end wall. The locomotive is *The Needles*, Southern Railway No. 2423, a former LBSCR H2 class 4-4-2, built in 1911 at their Brighton Works for express passenger services.

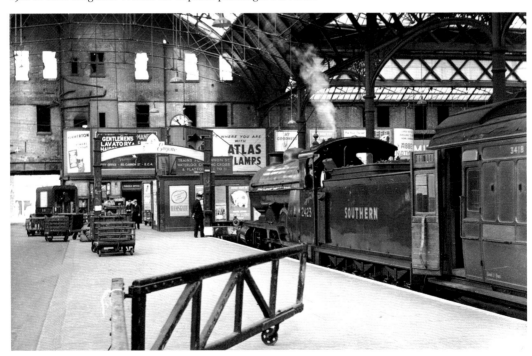

Above: A 1900 illustration from *The Illustrated London News* showing the annual exodus of hop-pickers leaving London Bridge station at midnight on 1 September on their way to Kent. *Below*: The LBSCR's London Bridge Railway Terminus Hotel, on the corner of St Thomas's Street and Joiner Street, opened in 1861. It was not successful, however, and was turned into company offices in 1892.

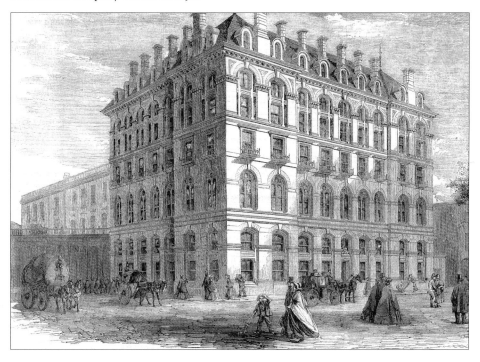

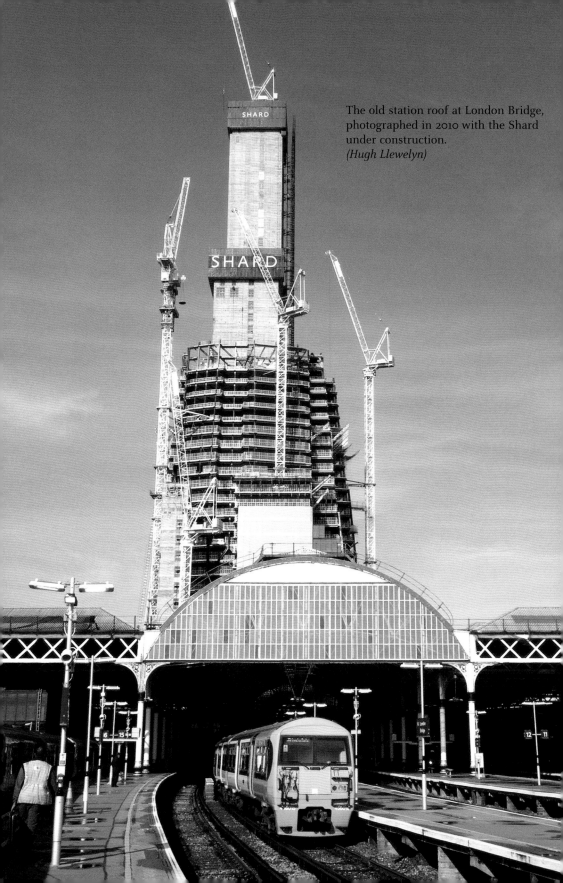

The old station roof at London Bridge, photographed in 2010 with the Shard under construction.
(Hugh Llewelyn)

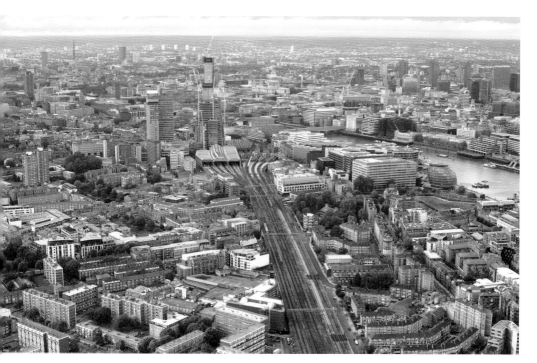

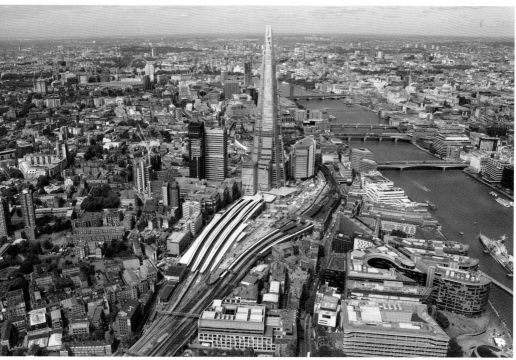

Above: This pair of aerial photographs shows London Bridge prior to the redevelopment of the station, and more recently with the work underway. The London Bridge Quarter Development includes the Shard, a new bus station and the new station with nine through platforms and six terminating platforms. The station handles around 56 million passengers a year. *(Network Rail)*

The nineteenth-century station

Above: The LSWR's Central Station facing on to Waterloo Road, with the bridge for the single track coming from the South Eastern line. The entrance ramp to the right passes under a wooden linking structure. *Below*: This plan from 1895 shows the original station in the centre, and the spur from the South Eastern line can be seen crossing the road. In effect old Waterloo consisted of three stations, each with their own passenger facilities, access roads and cab yards. Note the coal stages and turntable on the north-west side, between Griffin Street and York Road.

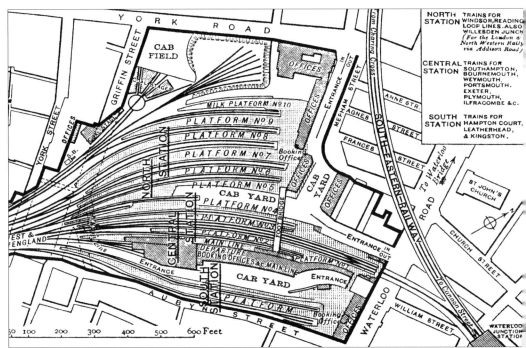

Waterloo

This is the biggest and busiest railway station in Britain with around 88 million people using it every year, not inlcuding those who travel on the Underground or neighbouring Waterloo East station. When all twenty-one platforms are in use – the two which served the Eurostar trains from November 1994 until 2007 are currently mothballed – Waterloo has more platforms and a greater floor area than any other station in this country. It is, therefore, all the more remarkable to learn that Waterloo was never intended to be a terminus at all.

When the London & Southhampton Railway's line was opened as far as Woking in 1838, its London terminus was at Nine Elms Lane on the Lambeth marshes to the south of Vauxhall Bridge. This was no further from the City than, say, Paddington, but the inconvenience of the river crossing made it seem remote. Renamed as the London & South Western Railway (LSWR), in 1845 the railway company obtained powers to build an extension to a new station in York Road and the Waterloo Bridge station opened in 1848, again intended only as a temporary measure until the line penetrated into London. In the event Waterloo expanded in piecemeal fashion throughout the remainder of the nineteenth century, resulting in a ramshackle and thououghly confusing collection of buildings and platforms. Consequently, in 1899 the board of directors decided on a total rebuild.

Among London's great termini, the present Waterloo has no parallel in that it almost entirely dates from the first two decades of the twentieth century. In essence it is an Edwardian structure, built in the angular and restrained architecture of the time – described either as Imperial Baroque or the British Empire style. Its crowning glory, the imposing Victory Arch, is flanked by the figures of War and Peace, and high above Britannia holds the torch of Liberty. Opened by Queen Mary in 1922, it is a memorial to the company staff who lost their lives in the First World war. Inside, the station roof might lack the sure hand and flare of the great Victorian engineers, but even so, it more than makes up for this in the sheer acreage of glass. In the ensuing decades Waterloo has been notable for the coming and going of the boat trains connecting with the great ocean liners docking at Southampton. It was from here that passengers travelled to join the *Titanic* on its ill-fated maiden voyage in 1912. The bow-shaped concourse has also echoed to the clatter of be-hatted race-goers on their way to Acot or Sandown, the wailing sirens of wartime, and the ebb and flow of a never-ending tide of commuters.

The international connection continued from November 1994 when Waterloo acted as the temporary terminus for the Eurostar service via the Channel Tunnel to Paris and Brussels. A new £120-million facility was created by hiving off Platform 20 and adding four additional platforms under a futuristic snaking curved roof of steel and glass. Elsewhere, the station's openness has been compromised by a wall of barriers and hoardings that cut off the view of the platforms. The latest addition is the retail balcony on the concourse.

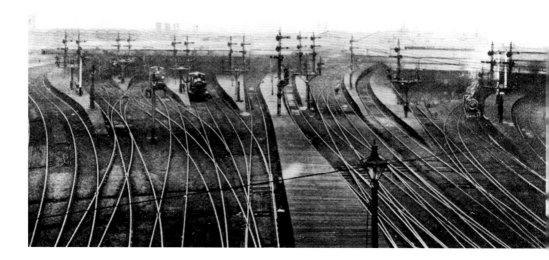

Above: An interesting view from the 'A' Box taken around 1900. A wooden extension from Platform 4 of the Central Station extends all the way to the signal box. The North or Windsor Station is set back on the left, along with the sidings going towards York Road. The South Station is shown on the far right. The rebuilding or 'Great Transformation', as it became known, took place over the first two decades of the twentieth century. The work was undertaken in piecemeal fashion, starting at the southern end and extending northwards, one step at a time.

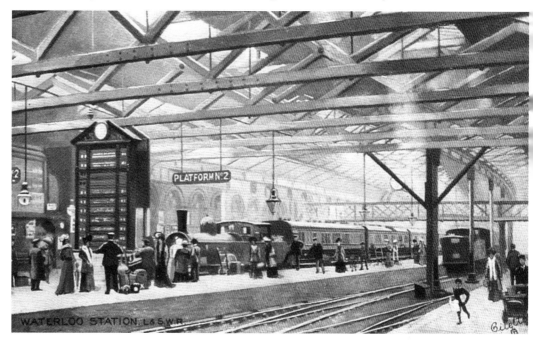

Above: A contemporary postcard, *c.* 1905, in the Raphael Tuck 'Oilette' series, depicting Platform 2 of the Central Station prior to the rebuilding programme. An LSWR tank engine is preparing for departure. The departures indicator board is on the left. Note the footbridge and clock in background.

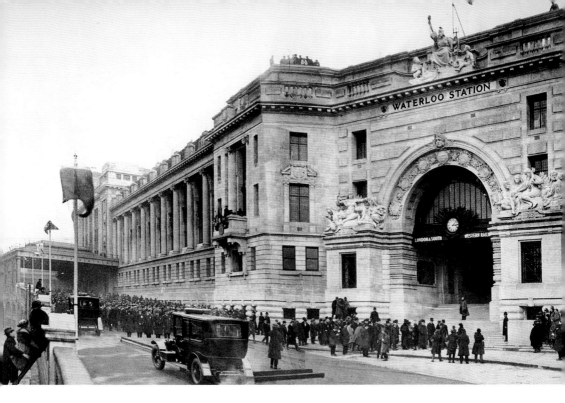

The new Waterloo

Above: On 21 March 1922 Queen Mary came to Waterloo, as the king was indisposed at the time, to officially open the completed station. She is shown entering the Victory Arch which commemorates the members of LSWR staff who lost their lives in the First World War. In most respects the view of the station from across the York Road has changed little over the ensuing years. The canopy for the cab entrance is on the left, with the main entrance canopy beyond.

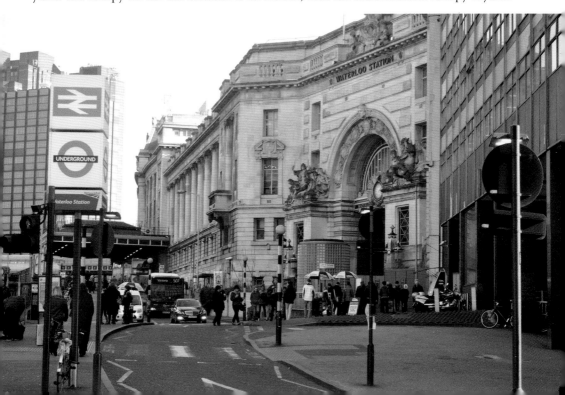

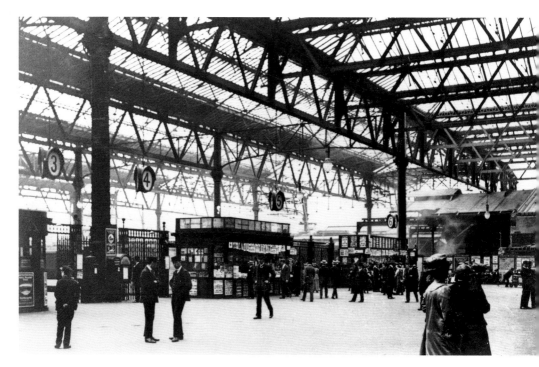

VOL.XLVI. No.3 MARCH 1961

MECCANO
MAGAZINE 1/3

WATERLOO STATION, LONDON

Above: The platforms at Waterloo are shown during the rebuild with some of the old station buildings in the background. The Edwardian engineers covered 24 acres with a ridge and furrow latticework of steel and glass, running at right-angles over the concourse and then transversely above the platforms. The octagonal support columns are substantial, although the modern paintwork and new glazing create a light and spacious feel.

Left: Electric suburban trains at platorms 2 and 3. The electrification programme was initiated by the LSWR in 1913 when the third rail system was adopted, the first trains running from Waterloo to East Putney in October 1915.

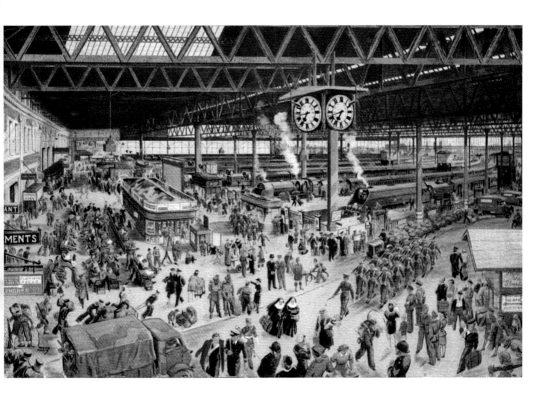

Above: Wartime at Waterloo in a poster by artist Helen McKie. In addition to the prominence of khaki, note the blackout on the glass roof and the cover on top of the station clock. *Below*: The new retail balcony was completed in May 2012 in time for the anticipated Olympic congestion.

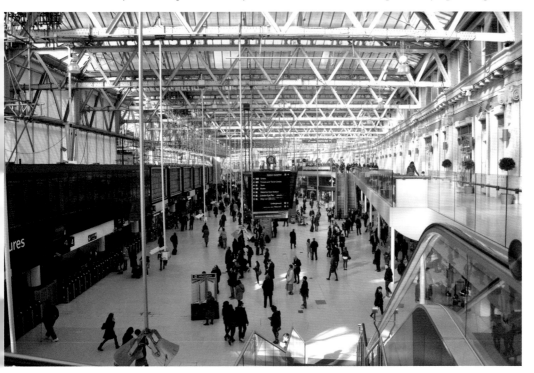

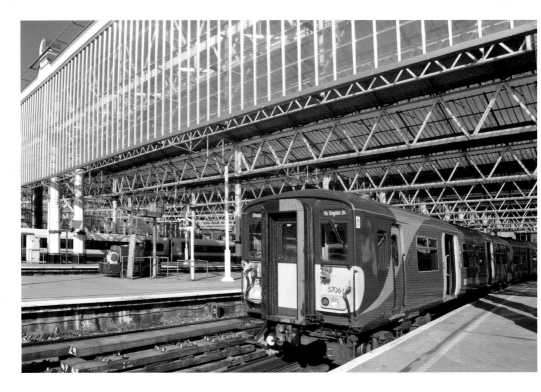

The refurbishment of Waterloo's 24 acres of glass has brought light into the station. *Above*: 5706 on Platform 4, going to Shepperton via Kingston. *Below*: In 1992 the remaining parts of the old North Station were swept away for the Eurostar terminal. This operated from 1994 until 2007, when the facilities at St Pancras were completed. *(Timothy Saunders)*

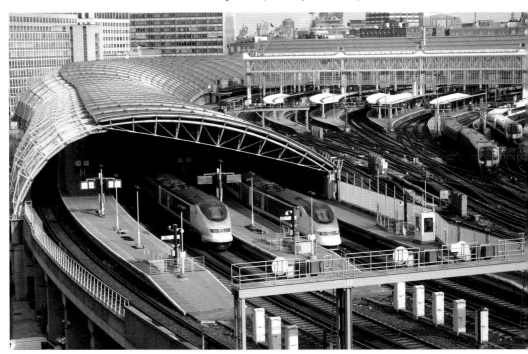

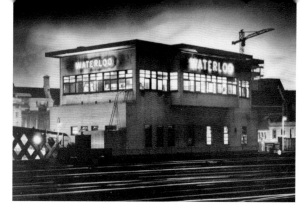

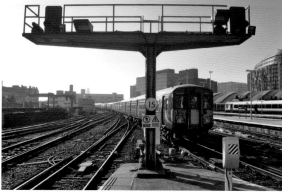

Above: The 1924 publicity photo that inspired the Southern Railway's most iconic poster. 'Yes, I always go south for sunshine by Southern.' The large 'A' signal box is in the background.

Top right: Southern Railway's modern 'all electric' signal box went into operation on 18 October 1936. Located on the east side of Westminster Bridge Road, the concrete box was closed in 1990 and demolished to make way for the Eurostar terminal.

Middle right: A present-day signal gantry with an incoming BR class 455 EMU, No. 5718, operated by South West Trains.

Bottom right: The Necropolis Railway had its own platform and, later on, this station building on Westminster Bridge Road. Its sole purpose was to transport London's dead via special trains to a new cemetery created at Brookwood, Surrey.

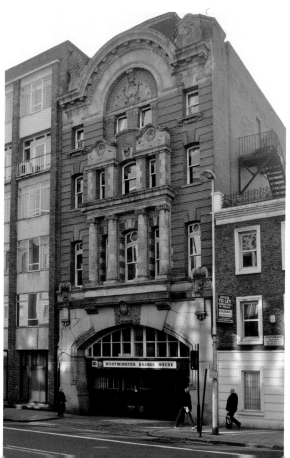

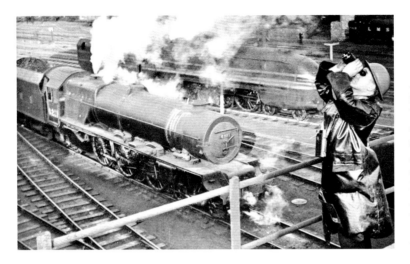

Left: During the Second World War, a rooftop spotter scans the sky for enemy aircraft as No. 6211, the Princess Royal Class *Queen Maude*, and an unidentified streamliner depart from Euston.

Further Reading

London's Historic Railway Stations, by John Betjeman, John Murray, 1978.
London's Termini, by Alan A. Jackson, David & Charles, 1969.
Paddington Station Through Time, by John Christopher, Amberley, 2010.
Victoria Station Through Time, by John Christopher, Amberley, 2011.
Euston Station Through Time, by John Christopher, Amberley, 2012.
King's Cross Station Through Time, by John Christopher, Amberley, 2012.
St Pancras Station Through Time, by John Christopher, Amberley, 2013.
Waterloo Station Through Time, by John Christopher, Amberley, 2013, revised 2015.

Acknowledgements

I would like to acknowledge and thank the many individuals and organisations who have contributed to the production of this book. Additional images have come from a number of sources and I am grateful to the following: Network Rail, US Library of Congress (LoC), Elliott Brown, Hugh Llewelyn, Barry Lewis, Paul David Smith, John Sturrock/King's Cross Central, Steven Vance, Alex Leceq, Andrea Vail, Ben Brooksbank, Timothy Saunders, Oxyman and Jorge Royan. Unless otherwise stated all new photography is by the author. Apologies to anyone left out unknowingly and any such errors brought to my attention will be corrected in subsequent editions. *JC*